DESTINATION:

Charlotte

[the book]

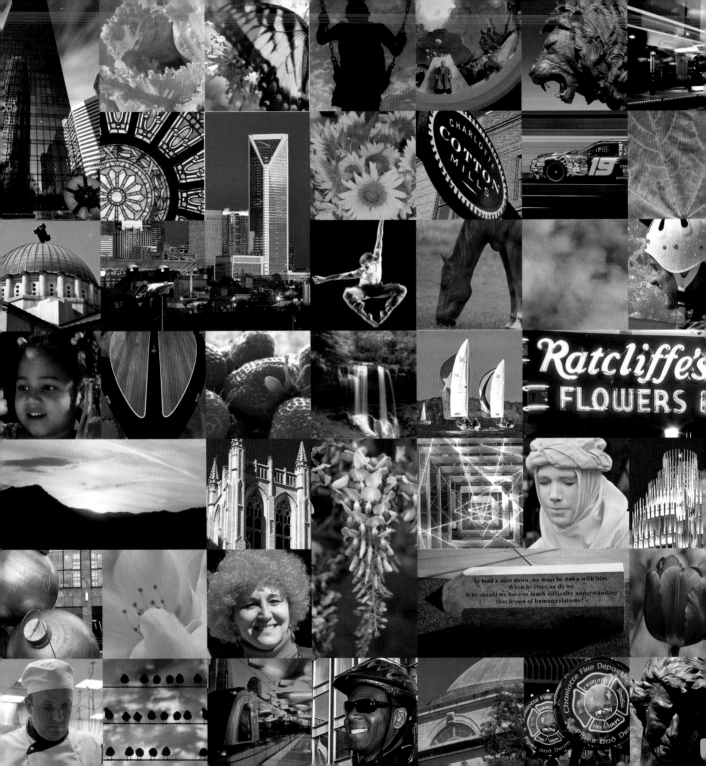

DESTINATION: *Charlotte*

[the book]

by
Greg Greenawalt

with photography by
Paul Purser

LORIMER PRESS
DAVIDSON, NC
2010

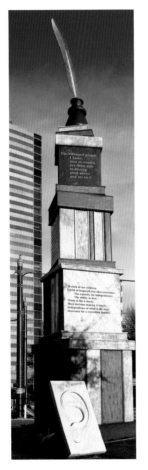

Text © copyright 2010, Greg Greenawalt
Photography © copyright 2010, Paul Purser
Additional photography credits & permissions page 156

Design © copyright 2010, Leslie Rindoks

Leslie Rindoks, editor
Published by Lorimer Press
Davidson, NC

Printed in China

ISBN - 978-0-9826171-1-3
(paperback)

Library of Congress Control Number: 2010931663

Dedicated to all the movers & shakers,

dreamers & doers who have made

Charlotte, NC a destination.

Table of Contents

INTRO

As a hospitality sales professional with Hilton Hotels, I am always looking for area-themed gifts for VIP clients and out-of-town dignitaries. In the spring of 2009 I looked in vain for a book that featured current images of Charlotte and the region. When I couldn't find one, I decided to create one myself, one that would truly represent the spirit of our great city.

Needless to say, finding the right photographer was critical. My friends Jim Bailey and Eddie Burklin at Red Moon Marketing suggested I talk with Paul Purser. Paul and I hit it off at our first meeting and then got right to work.

Exploring Charlotte and the Piedmont region became a yearlong odyssey. We were often up at 4 A.M. because the best light, according to Paul, is early morning. Weather was always a factor, especially with date specific festivals and events that gave us only one opportunity to shoot—rain or shine.

We traveled hundreds of miles and met some extraordinary people along the way. We encountered cooperation and support everywhere we went—a great example of the "can do" spirit and hospitality our region is known for.

I am especially indebted to others who contributed many of the words that accompany Paul's pictures. Sincere gratitude to Bob Morgan, Bruton Smith, former mayor Harvey Gantt, Winston Kelly, Michael Smith, Maguerite Williams, Ronnie Bryant, Tim Newman and Allen Tate for their support, interest, and valuable time. In addition, there are many, many others who opened doors—literally and figuratively, guaranteed access, checked facts and provided additional images. Thank you all. (Though we have tried to list everyone in the acknowledgements, our apologies to anyone whose name we inadvertently omitted.)

Thanks to Paul Purser for his incredible talent and perseverance, and to his wife Susan who also was along for the ride and helped in countless ways. Thanks to my editor, Leslie Rindoks, whose expert word-smithing has taken my comments to the next level, and for knitting words and pictures together so seamlessly. And to my family for their patience and support during this twelve-month process.

It's an honor to share this exciting, new perspective of Charlotte and the region with everyone—longtime Charlotteans, newcomers, and visitors alike.

—*Greg Greenawalt*

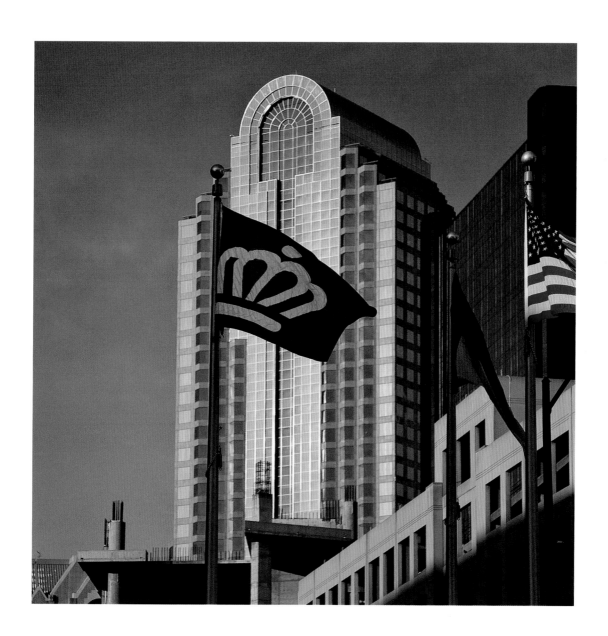

LIVE

From the first, a crossroads

Charlotte sprang from the convergence of two native American trading routes — the Nations Ford Trail south to Charlestown and the Great Trading Path north to Virginia. The area was originally home to the Catawba Nation with six villages that spread along the banks of the Catawba River. In the 1750s, settlers and fur traders, many with Scots-Irish, Swiss, and German heritage, followed the well-established Catawba trails and began settling in what was called the Carolina Backcountry.

The Queen City

In 1755, Thomas Polk and his wife Susannah Spratt built their home near the crossroads of the two trading routes, the current location of Trade and Tryon Streets. A scant five years later, in 1760, residents incorporated the fledgling community as Charlotte's Town in honor of Queen Charlotte, the bride of England's King George, III with the hope that the crown would award them with a county courthouse. In 1762, Mecklenburg County was named after the Queen's birthplace, Mecklenburg Strelitz Germany.

Charlotte's Independent Streak

Charlotte's independent spirit was evidenced early when Mecklenburg delegates declared themselves free and independent from British rule and laws by signing The Mecklenburg Declaration of Independence on May 20, 1775. In September, 1780, during the Revolutionary War, British troops, led by Lord Cornwallis and Colonel Tarleton, marched on Charlotte and occupied the city. On the McIntyre farm, near Beatties Ford, local farmers and militia fired on Tarleton's 300-man army. During the battle, now known as the Battle of the Bees, colonial militia included numerous bee hives as part of their artillery. As a result, the British were severely stung and soundly defeated. After this loss, Cornwallis deemed Charlotte "a hornets' nest of resistance."

Since then, Charlotte's 200-year history is rife with examples of independent thinking and entrepreneurial successes, from mining, farming and manufacturing to power generation, transportation and banking.

RIGHT, FROM TOP: *Cabin where James K. Polk (11th U.S. President) was born in 1795; the Mecklenburg County Courthouse; and "The Future" by sculptor Raymond Kaskey at Trade & Tryon.*

FAR RIGHT: *Queen Charlotte, by Raymond Kaskey, at Charlotte Douglas International Airport*

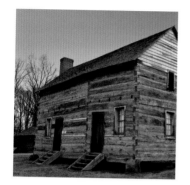

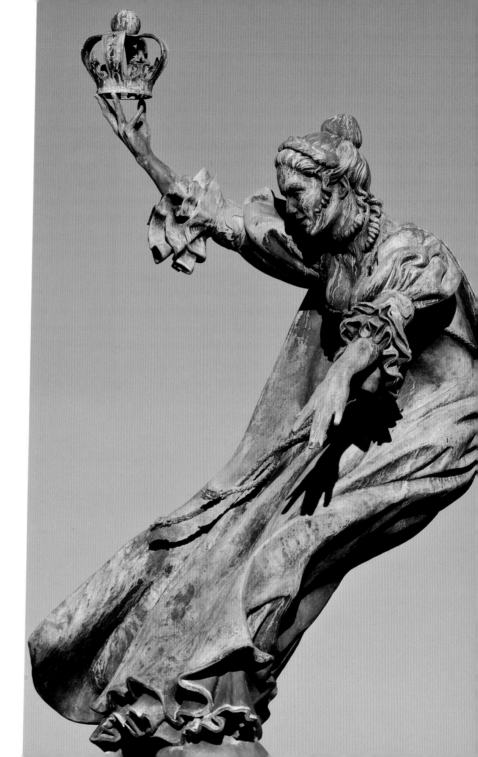

Charlotte, A DESTINATION FOR MANY

During the last decades of the twentieth century, Charlotte enjoyed incredible growth, with new residents pouring in from all over the country and around the globe. In large part, this was because the city offers many of the benefits associated with living in a major metropolitan city as well as charm, quality of life, and family values. In 2007, the Charlotte Regional Visitors Authority commissioned an extensive study to identify Charlotte's values, perceptions and attitudes as defined by urban, suburban and rural residents, business owners and visitors. The following description of Charlotte and the surrounding communities emerged:

> "With its warm, friendly people and inviting Southern hospitality, Charlotte is a clean, beautiful and diverse contemporary city that is a dynamic financial center with an ambitious can-do spirit.
>
> With its trees, lakes and green open spaces, the region is steeped in NASCAR heritage and has a commitment to community that embraces the innovative, aspires to the best in all of its endeavors while preserving traditions and not compromising on a superb quality of life."

ETHNIC COMPOSITION

One out of every eight Charlotte residents was born in another country.

60% CAUCASIAN
30% AFRICAN AMERICAN
10% OTHER

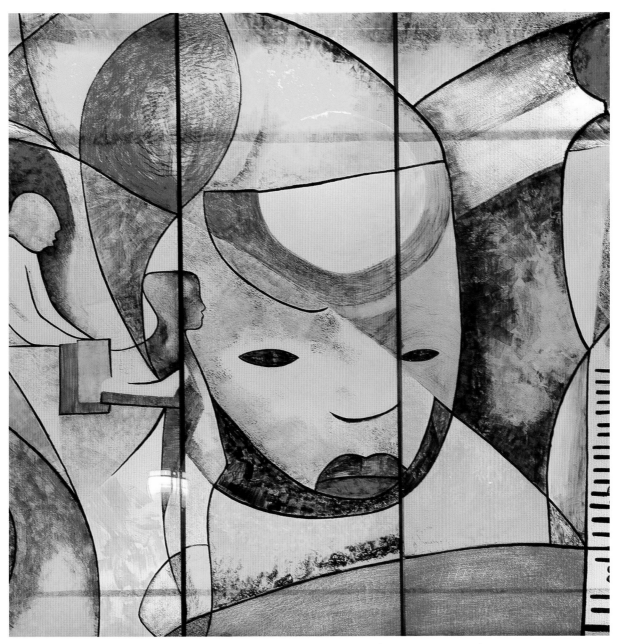

Detail from mural "Divergent Threads" by David Wilson at the Harvey B. Gantt Center for African American Arts & Culture

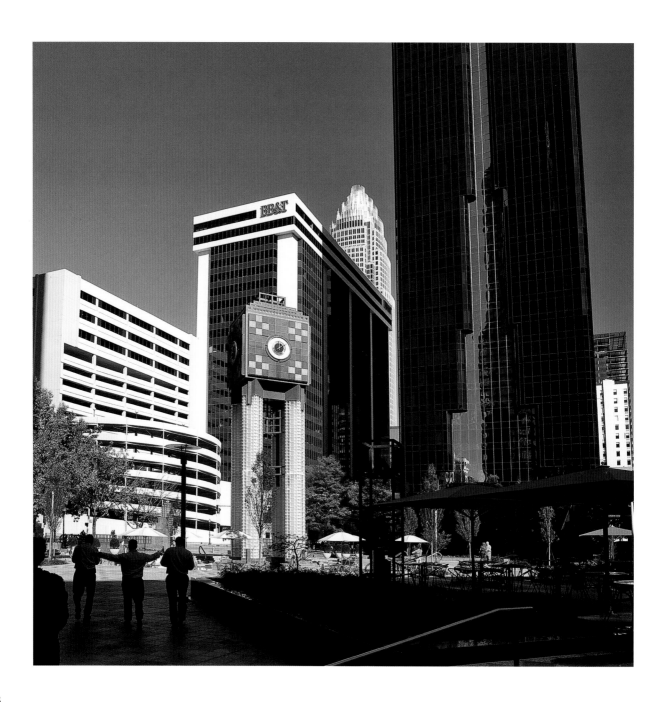

Charlotte offers abundant housing options, from the urban lifestyle in a plush high rise condo or refurbished loft, to an elegant town home or a single family residence on a quiet, tree-lined street.

Lakes Norman and Wylie are short distances from uptown while the city's ideal location means the Blue Ridge Mountains are but three hours to the west and Carolina beaches are only a few hours ride to the east.

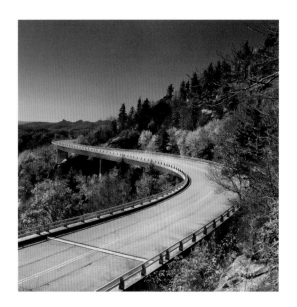

"Go to Charlotte, son!"

Real estate titan Allen Tate says Charlotte vibrates!

According to Tate, Charlotte vibrated even back in 1957. After Tate graduated from college, his daddy, down in Gaffney, SC, encouraged him to pursue real estate and said, "Go to Charlotte, son." So April 15th, 1957, Allen Tate opened a small office in the Liberty Life Building near the square at Trade and Tryon. "The wheels were turning so fast you couldn't hardly make a mistake," Tate says. Fifty years later, Allen Tate Realty had grown to be one of the nation's largest independent realty companies.

"There is still a certain vibrancy and spirit in Charlotte. Other southern cities come close, like Dallas and Atlanta, but they don't have 'it.'" And if you ask Tate, he'll tell you the "it" is part blessing and part attitude.

"In this WOW city," Tate says, "we are blessed by geography. The mid-Piedmont crescent has all four seasons, plus the mountains to the west, the sandhills and beaches to the east." Charlotte is also ideally located near the Catawba River. "The Catawba River is why Duke Power is here." Tate credits the Catawba tribe with preserving the river which now includes several power lakes, including two that bracket the city: Lake Norman, to the north, and Lake Wylie, to the south.

Geographically we've always been a crossroads and we've worked hard to preserve that. In the early 1900s, when civic leaders learned the railroad was planning to run through Lincolnton, they raised $25,000 to move the track through Charlotte. "You cannot say enough about Charlotte's public-private partnership," Tate says. "None of us have THE answer, but get thirty people in the room and things happen!" On more than one occasion he's been in a windowless room with twenty-nine others and everyone has had their checkbooks at the ready, all willing to underwrite a cause. From supporting the Arts &

Science Council to attracting major league sports—the "WOW stuff" Tate calls it—things happen because of private partnership.

The attitude of the people in Charlotte has always been to keep moving forward. "Old isn't everything," they say. "We want bigger and better!" In the mid-twentieth century, Tate says, we wanted to create a city; we wanted to be a success, not a failure. We wanted to build the New South.

"Charlotte had a real awakening back in 1955 when Celanese moved to town. Some of those folks up North were not sure we wore shoes here in the South," Tate recalls. The transplanted Celanese employees were not happy. "'Why doesn't everyone love Charlotte?' we wondered. No liquor by the drink; no culture, they said." Tate says that's no longer true. We have culture, we have diversity. The sidewalks don't roll up at nine P.M. anymore.

Some of the visionaries that enabled Charlotte's incredible growth include Mayor Stan Brookshire who knew Charlotte needed a world class airport. Today, Charlotte-Douglas International Airport is the single reason many choose to live here. "People love the beauty and the climate," Tate says, "but knowing they can hop on a plane and do business anywhere, that's the deal closer." Another shining example is Bonnie Cone, who took Charlotte College and transformed it into UNC-Charlotte, and watched as fields populated by a lone nursing home blossomed into University City. "Bonnie's a saint," says Tate.

There is also a strong aesthetic sensibility in Charlotte. We spend more on design and architectural details than many cities. Plus we consider our tree scape to be extremely important. "Planting trees is not due to regulation, but because it's what developers WANT to do," Tate stresses. "As a developer, I've planted more trees than I ever tore down, all because I wanted to!"

Tate is bullish on Charlotte. "We'll be able to weather any downturn," he says. To remain on top, Charlotte needs people with vision. "We'll have to keep creating things," he says. "Our city should have living, breathing parks, an uptown university, a research hospital and more sports teams." As for the future, he says, we'll continue to be a real estate mecca. "Continuing to attract corporations is the key. Where there are jobs, families fare well. Young people return here after college, second careers are launched here, people retire here. We have excellent facilities for every age.

"It's a city that's going places, I tell you. You can plug in here!"

- *RelocateAmerica.com ranked Charlotte #1 in America as Best Places to Live. (2008)*

- *CNNmoney.com ranked Charlotte as the eighth best place in the U.S. to live and launch a business.*

- *Charlotte's median household income is $55,439 while NC's household median income is $46,574 and the U.S. Household median is $52,029. (2008 census)*

- *Average home price in Charlotte is $295,553. (Trulia Real Estate Search)*

- *Charlotte's cost of living is 9.3% lower than the U.S. average.*

- *In 2010, Charlotte ranked as the 18th largest U.S. city.*

"On Saturdays, I enjoy taking a quick spin through Uptown or South End, just to catch the vibe for that weekend. I find people and families of all ages enjoying the energy, whether they are walking their dogs, enjoying museums, reading the paper at a sidewalk cafe, or engaging in lively debate.

Center City neighborhoods weave restored Victorian homes with quaint bungalows, charming town homes and gleaming high rise condominiums as well as apartments.

Our cultural, culinary and nightlife offerings become more sophisticated and varied by the day. We have delightfully funky and quirky corners. It is more than an address; it is a lifestyle."

—MICHAEL J. SMITH
President & CEO
Charlotte Center City Partners

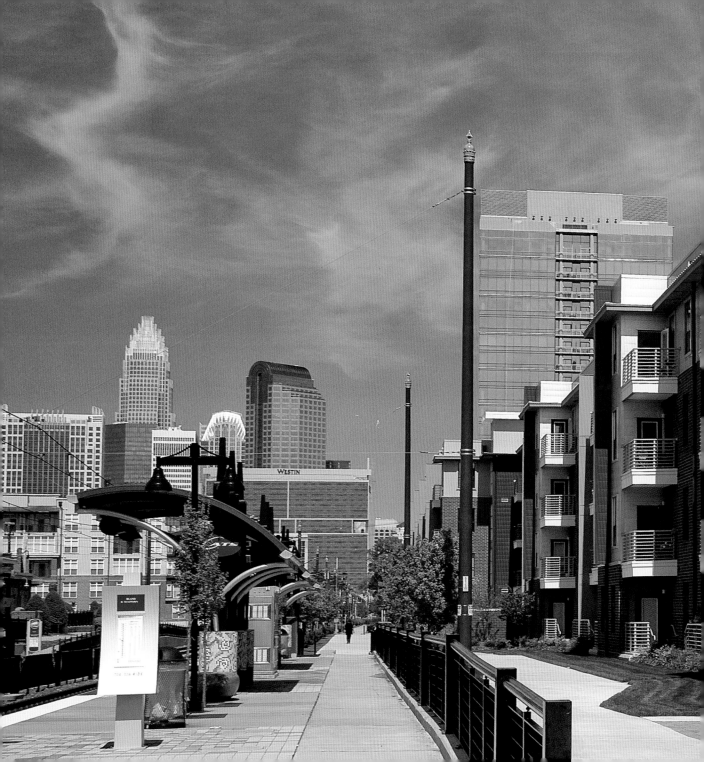

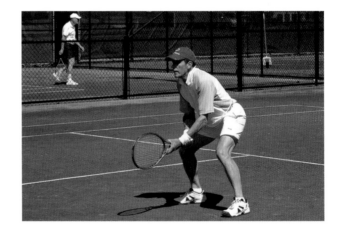

Dell Webb Sun City Carolina Lakes, located in Lancaster County just south of Charlotte, is a senior living community with many "young at heart" amenities—including a golf course, fitness center, indoor and outdoor pools, walking trails, and a lake for kayaking and canoeing.

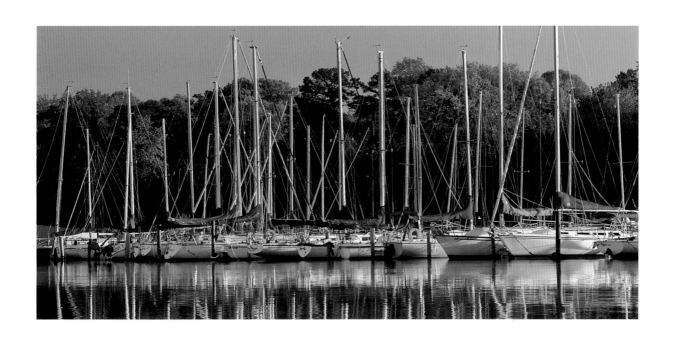

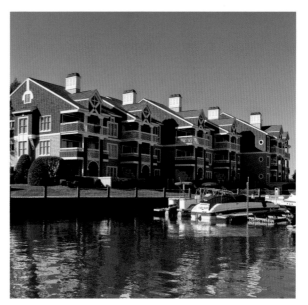

Life on Lake Norman

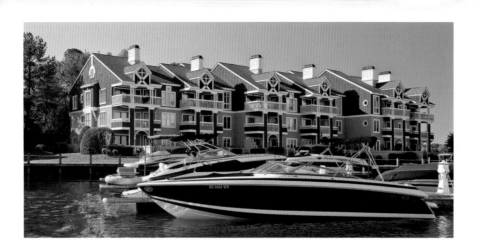

"Living on the lake
is like being on
vacation every day.
I rarely choose to
travel anywhere else."

—PATTY ANDREWS
*Lake Norman resident
since 1986*

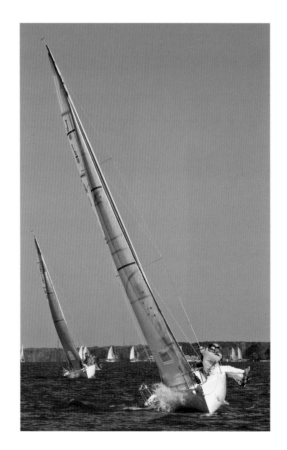

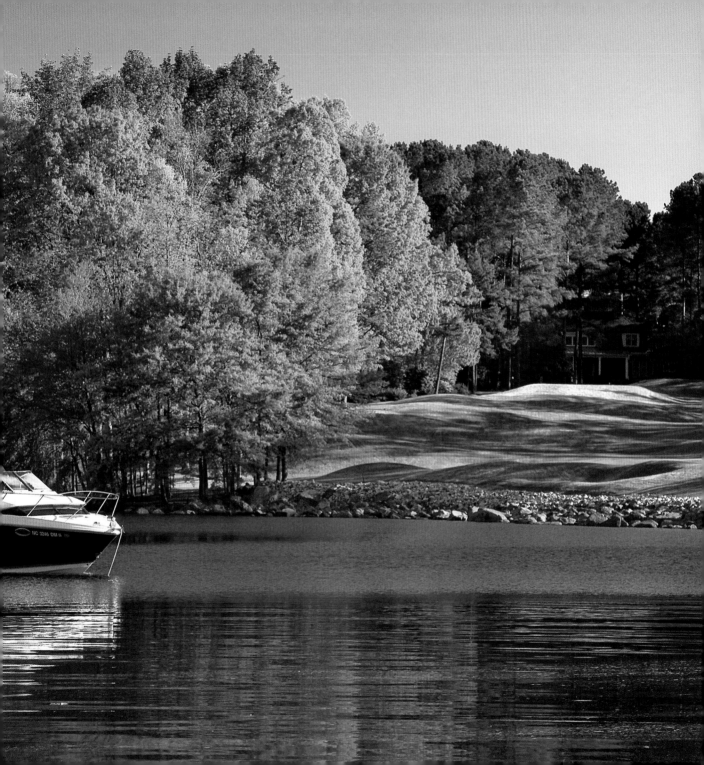

Affordable & Attractive

Davidson, NC won the highest award possible for affordable housing in 2002. Davidson Town Commissioner Marguerite Williams thinks that's because the town did it right the first time. First, they listened.

The Town of Davidson was incorporated in 1879, some forty years after Davidson College was established. Its citizens have always been involved in the life of the town. According to Williams, a large factor in the town's success is its connectivity. "Most people *crave* community," she says. "In fact, the biggest leading indicator for avoiding a recurring health event, such as a stroke or heart attack, is identifying yourself as living in community. Polls indicate that Davidson consistently scores high on feeling connected. Connectivity here is the watchword."

Williams arrived in Davidson in 1977, fresh from the University of Texas where the student population numbered more than 40,000. Davidson at the time, was barely a tenth that size. *What will I do here in this tiny town?* she wondered. While her husband Bill was busy setting up Davidson Clinic, she found herself playing a role in community relations, building bridges between neighborhoods.

Then as now, there was a distinct cooperative nature in Davidson. "Davidson is not a fancy town; it's modest due to our Scottish heritage — we're thrifty," Williams explains. "We were one of the first towns to have recycling bins at every house," she adds. Townsfolk founded co-ops such as The Children's Schoolhouse, a preschool, and the Swimming Hole, a neighborhood pool; both were begun well over a generation ago and are still going strong.

By 1994, however, the handwriting was on the wall; Davidson was about to grow. "No longer would we be a sleepy little village. Davidson has long been a small town with a diverse population, but now our traditional mix was threatened by rapid growth and skyrocketing property values. We wanted to protect both our small town character and our diversity." The Town adopted a Land Plan to preserve its small town way of life. This plan outlawed sprawl and stated that new development should reflect Davidson's citizens' values and desires. "We wanted houses with porches; sidewalks on both sides of street; streets engineered for slow traffic; and greenways for cycling and walking. From this plan, design imperatives evolved with a mandate that all new neighborhoods connect to existing and future development."

To remain a sustainable and vital small town, the town also committed to maintaining and nurturing its diversity. One bedrock value for Davidson was that a sustainable small town must provide a variety of housing price points. There was a push then for larger, more lavish homes. With the addition of River Run, Davidson now included a golf course community. To maintain its racial and socio-economic balance, Mayor Russell Knox appointed an Affordable Housing Committee in 1995. The group ultimately determined that a new organization should be formed, not to duplicate the efforts of Habitat for Humanity, but to provide rental units and developer-built houses bought with standard mortgages. In 1997, the Davidson Housing Coalition (DHC) was formed with Williams as its first president, a post she continues to hold more than a decade later. DHC sought to create housing that was affordable; not isolated, but part of developed neighborhoods. In other areas of the country, early experiments in affordable housing unfortunately were not pleasant, livable environments. "People thought 'projects' when they heard affordable housing," Williams recalls. "We had a hard sell at first."

To change people's perceptions, DHC first had to earn their trust. They hosted a series of workshops where

citizens could communicate their concerns and wishes. Workshops reviewed the history of affordable housing initiatives: What had worked? What hadn't? The workshops included hands on designing with bulletin boards and push pins and cutouts of trees, cars, houses and sidewalks. Developers and town staff listened. Williams says, "We heard Davidsonians wanted detached housing built of high quality materials. 'Not stacked; not attached.' They wanted housing that looked like houses. John Burgess, our architect, went back to the drawing board. His plans changed from townhouses to bungalows." The final plan included 32 units in nine detached bungalows. Because bungalows were a predominant architectural style in older parts of Davidson, they "looked immediately at home."

With the aid of some state funding, DHC was able to break ground in 1999. The Bungalows won many awards, including the national Maxwell Award for Excellence in Affordable Housing. "More importantly," says Williams, "Bungalow residents and their neighbors were pleased with these new housing options." This initial success in the affordable housing arena led to subsequent ventures spread across the town. Ten single family affordable homes were built in DeerPark, a multi-use community that includes business, retail and a waterfront park. Additional homes were built at Creekside and in the St. Alban's neighborhood.

Today, 12.5% of all new residential development in Davidson must be built and sold in the affordable range. "Affordable housing in Davidson is cozy. These homes have nice yards and flower-filled gardens," Williams says. Potential owners must earn 80% or less of the area medium income to qualify. "Many are occupied and owned by teachers and law enforcement officers; people that we are privileged and proud to live near. Our goal here was to create pleasant, sustainable communities. I think we succeeded."

Located in the northwest corner of Union County, approximately 15 miles from Charlotte, Weddington and Waxhaw originally belonged to the Waxhaw tribe and have a rich history with both the Revolutionary and Civil Wars. Weddington and Waxhaw offer quaint small town charm where the majority of residents enjoy single family homes on lots of more than one acre. The area is also home to many horse farms and stables.

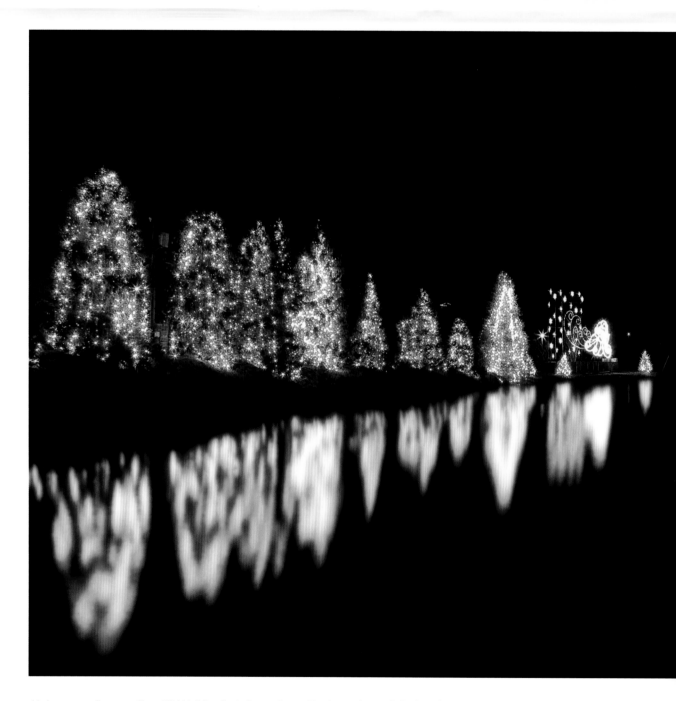

McAdenville at Christmas: Since 1956 McAdenville, in Gaston County 20 miles northwest of Charlotte, has been known as Christmas Town USA.

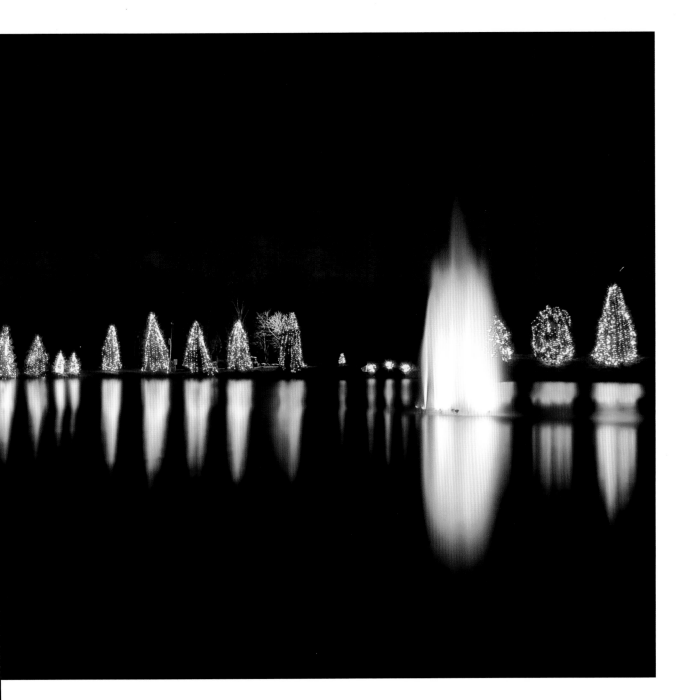

Every year, December 1-26, McAdenville's 600+ residents turn their town into a dazzling display of holiday magic that draws thousands of visitors.

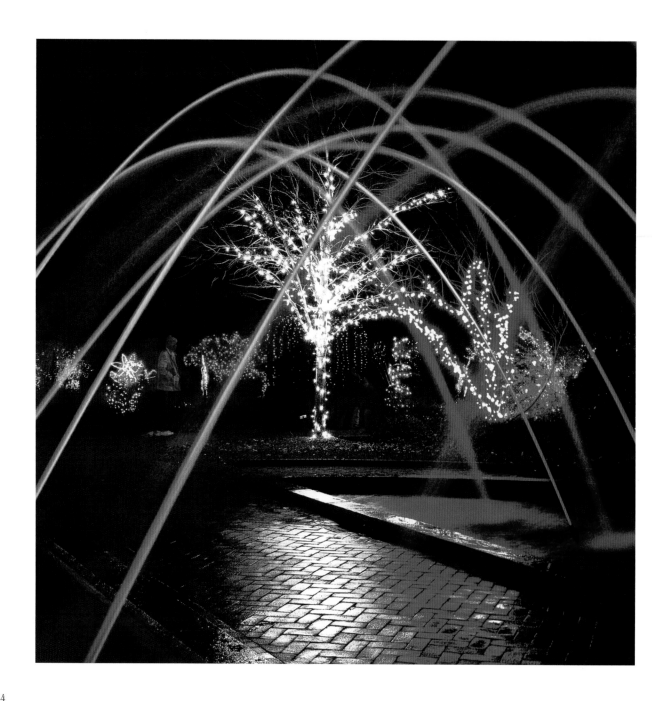

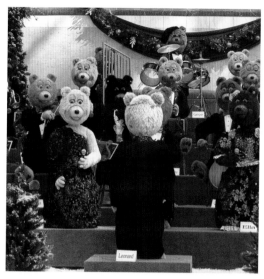

Holiday decorations in and around Charlotte. LEFT: *Lights at Daniel Stowe Botanical Gardens.* ABOVE, CLOCKWISE FROM TOP LEFT: *Giant decorations at Wachovia, Wells Fargo; Bernstein Bears at Founders Hall at Bank of America; toy soldiers at the Blumenthal; and the tree at Birkdale Village in Huntersville.*

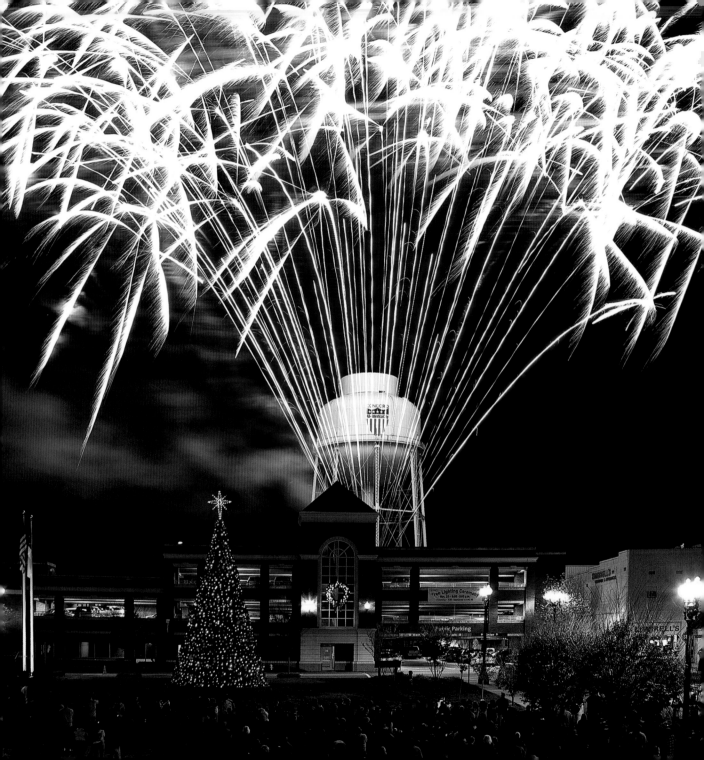

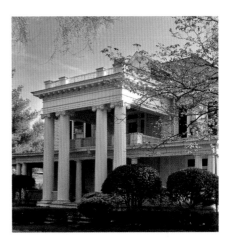

"Living on Concord's historic North Union Street is like stepping back in time. Our children grew up walking to school, to church, to the library, and downtown to the square.

You can't help but sense those first settlers of the town and those early textile magnates who enlarged and enlivened our neighborhoods!"

—PEG MORRISON,
long time Concord resident

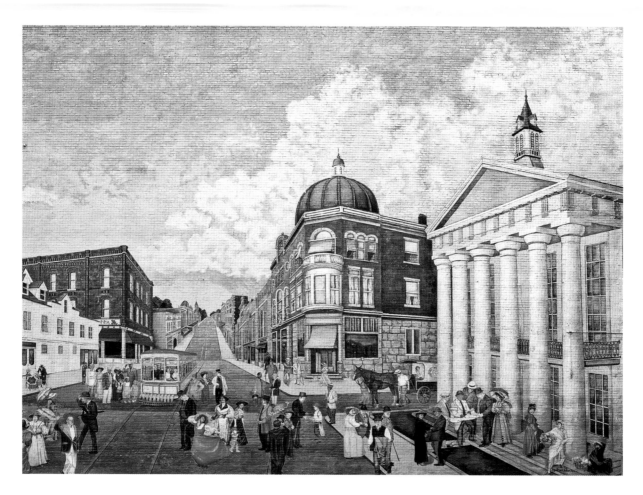

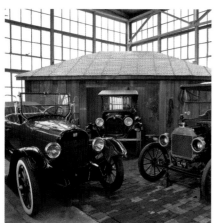

Salisbury, North Carolina is in Rowan County. This charming town exudes history with ten National Register Historic Districts—from the early days of Daniel Boone and Andrew Jackson through the Civil War and General Stoneman's raid, and on into the golden age of rail transportation. Salisbury is home to the North Carolina Transportation Museum with a great display of historic cars and trains and a functioning roundhouse. (Historic Salisbury mural is by artist Cyndy Arthur-Rankin.)

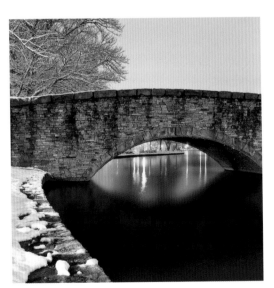

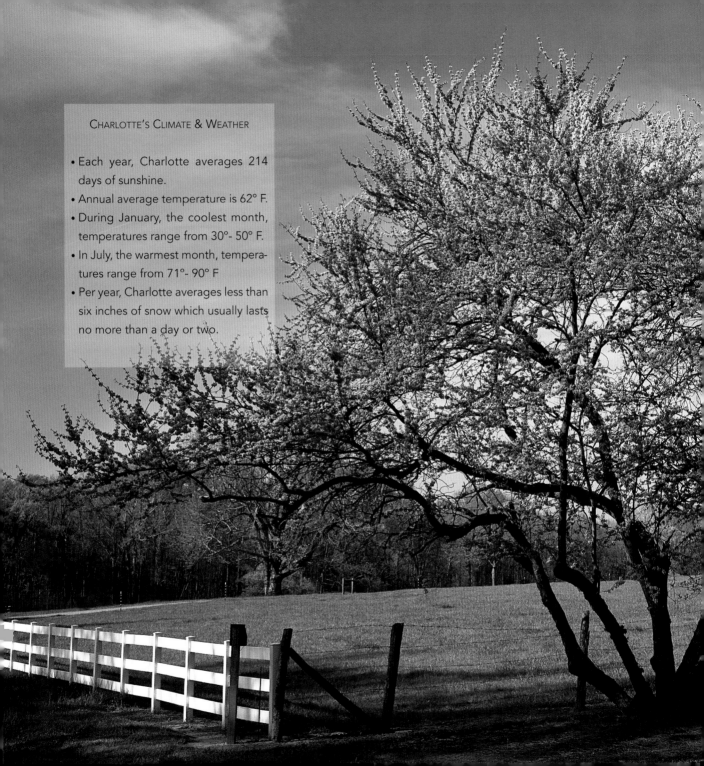

Charlotte's Climate & Weather

- Each year, Charlotte averages 214 days of sunshine.
- Annual average temperature is 62° F.
- During January, the coolest month, temperatures range from 30°- 50° F.
- In July, the warmest month, temperatures range from 71°- 90° F
- Per year, Charlotte averages less than six inches of snow which usually lasts no more than a day or two.

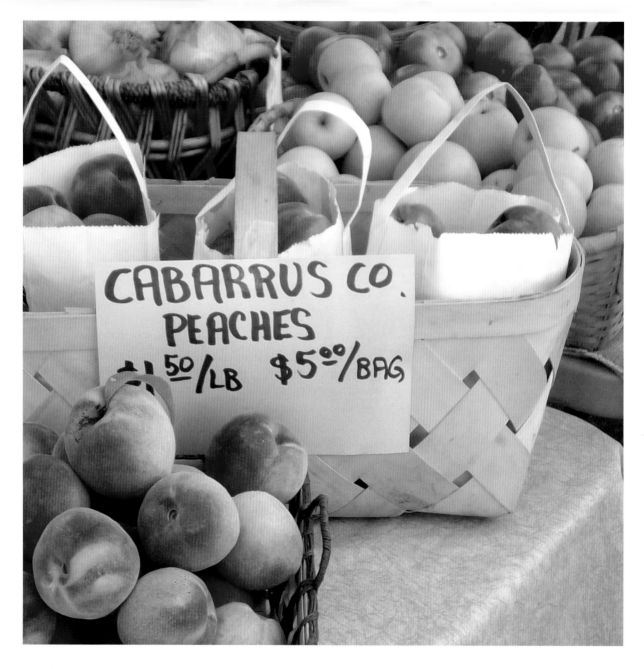

Bountiful farmers' markets across the region yield fresh, organically grown produce, herbs, flowers, locally raised beef, pork and poultry, and more. In addition, there are many "pick your own" farms in the area for those wanting only the freshest strawberries, peaches and apples. Above and far right are produce from the Piedmont Farmers' Market, in existence since 1984.

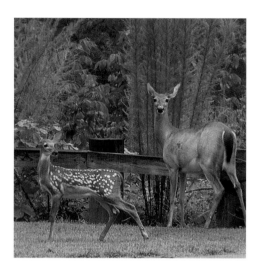

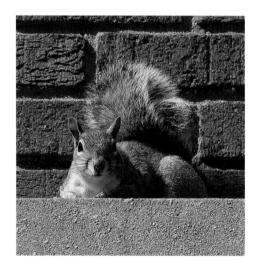

Wildlife is abundant in the Charlotte area. Deer, squirrels and the occasional bear are sighted, as well as birds of prey and egrets and osprey on nearby lakes. RIGHT: *Photographer John Daughtry captures the beauty of a bluebird as it comes in for a landing.*

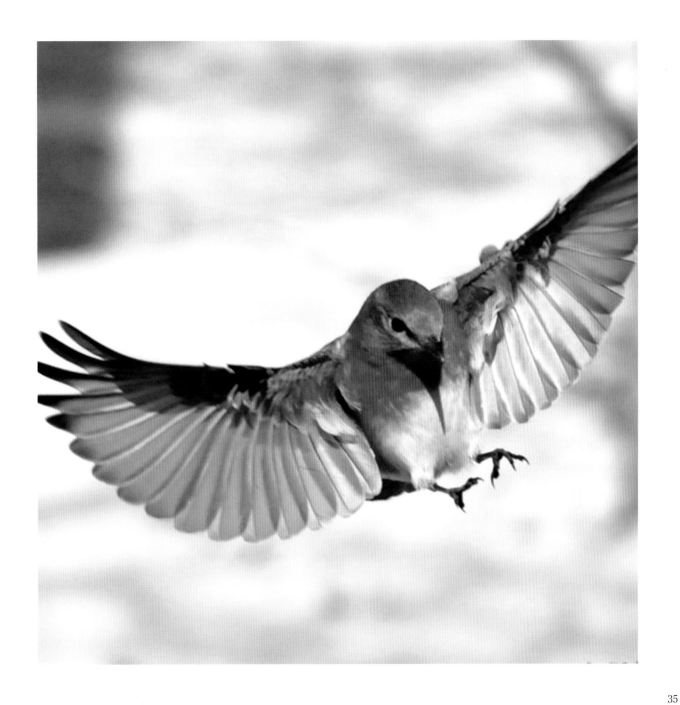

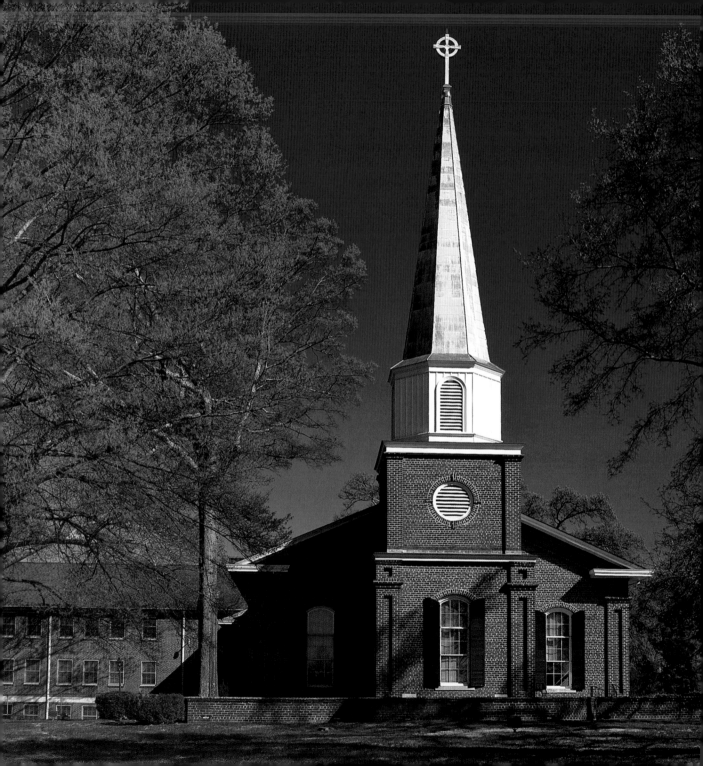

LEFT
*Sugaw Creek Presbyterian Church is the oldest
church in Mecklenburg County, the mother
church for the seven original Presbyterian
congregations in Mecklenburg County
established before the Revolutionary War.*

*The church was established in 1755 on land
assigned by the crown to colonial land agent
John Selwyn.*

RIGHT
*First Presbyterian Church of
Charlotte was organized at its present
location in 1821 and the first church building
was dedicated in 1823.*

*Dr. Robert Hall Morrison, the congregation's
first minister, later became the first president
of Davidson College.*

*The second building was erected on the site in
1857, The Gothic revival architecture style of
this building has been retained through all
subsequent additions.*

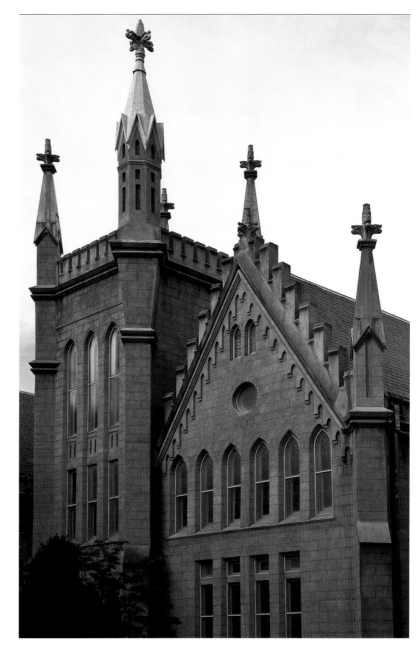

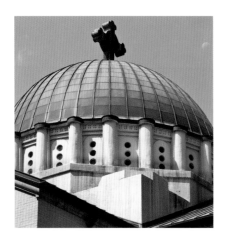

The dome of Holy Trinity Greek Orthodox Church on East Boulevard; Myers Park Baptist Church on Queens Road

BELOW

Calvary Church's cathedral measures 2.5 million cubic feet and seats more than 5100. Architecturally, the building was designed to resemble a crown.

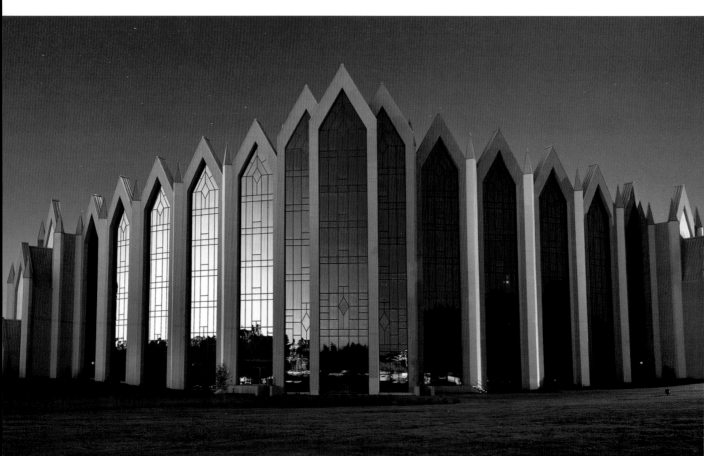

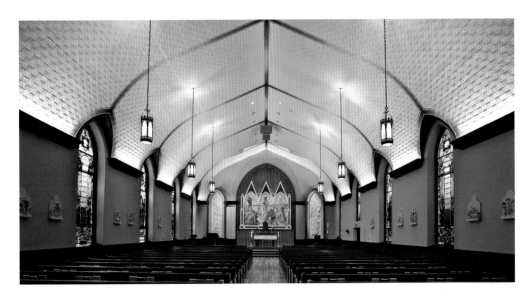

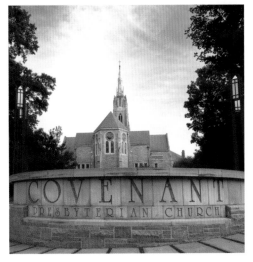

TOP: *St. Peter's Catholic Church on Tryon Street*
BOTTOM: *First United Methodist Church on Tryon Street, and Covenant Presbyterian Church on East Morehead Street*

Temple Israel in Shalom Park

A destination for Christians worldwide, Inspiration Ministries' City of Light campus in Lancaster County, South Carolina houses an extensive multimedia production facility, amphitheater and children's outreach center. (Bronze sculptures by Mark Patrick)

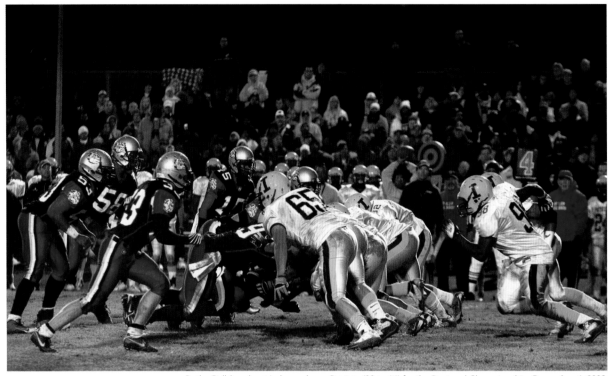

Butler Bulldogs beat Independence Patriots (38 to 14) for the Regional Championship, December 4, 2009.

EDUCATION

Charlotte offers a wide array of educational institutions at all levels and has been ranked as the sixth most literate city in the country based on the percentage of residents holding a high school diploma or greater and the percentage of residents with bachelor degrees.

CHARLOTTE MECKLENBURG SCHOOL SYSTEM
- 172 schools with 134,000+ students
- 99 Elementary Schools
- 31 Middle Schools
- 33 High Schools
- 9 Special Programs

INDEPENDENT SCHOOLS
- 64 private schools with 20,000+ students

CHARLOTTE AREA UNIVERSITIES & COLLEGES
85% of Charlotte area high school graduates continue their studies at institutions of higher learning.

Charlotte and the surrounding 13-county area boast 34 colleges, universities and technical institutes. Eighteen of these offer four-year degree programs, while twelve offer graduate degrees.

Davidson College

Consistently regarded as one of the top liberal arts colleges in the country, Davidson College has graduated 23 Rhodes Scholars since its establishment in 1837 by Presbyterians. A longstanding Honor Code continues to be central to student life at the college. Davidson offers 20 majors, interdisciplinary majors and 12 concentrations. The college competes in NCAA athletics at the Division I level and is located north of Charlotte in Davidson, near Lake Norman.

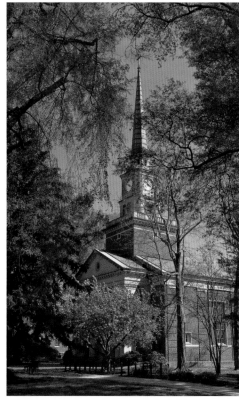

QUEENS UNIVERSITY

Queens University, founded in 1857, is a private liberal arts university with close ties to the Presbyterian Church. Queens has approximately 2,300 students enrolled in its college of Arts and Sciences, the Pauline Lewis Hayworth College and the McColl Graduate School of Business. The University is located in Myers Park, near uptown Charlotte.

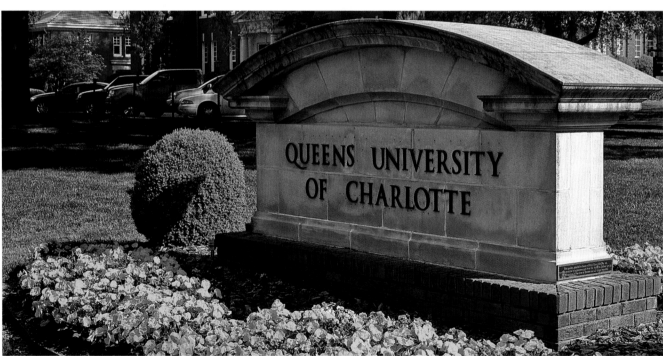

Johnson C. Smith University

One of the nation's oldest African American institutions of higher education, Johnson C. Smith is a private four-year liberal arts school with a 100-acre campus located on the edge of Charlotte's center city. The university enrolls 1,500 students and offers over 30 fields of study leading to Bachelor of Arts, Bachelor of Science or Bachelor of Social Work degrees.

HOME OF THE
GOLDEN BULLS

University of North Carolina – Charlotte

UNC-Charlotte, with 23,000 students, is the fourth largest campus in North Carolina's 16-campus collegiate system. The school offers degrees in 90 programs that lead to Bachelors Degrees; 62 fields of study leading to Masters Degrees; and 18 leading to Doctoral Degrees. As a Research University, the school is home to seven colleges, including the schools of Architecture, Arts and Sciences, Business, Engineering, Education, Information Technology, Health and Human Services, and the School of Nursing.

JOHNSON AND WALES UNIVERSITY

Johnson and Wales' Charlotte campus includes the College of Business, the College of Culinary Arts and the Hospitality College located in Charlotte's uptown center city.

Established in 2004, the school serves 2,500 students with state-of-the-art business and culinary facilities featuring a showcase street front baking and pastry laboratory, visible to local pedestrian traffic.

CHARLOTTE SCHOOL OF LAW

Charlotte's only law school is accredited by the American Bar Association and offers full time, part time, and evening classes. Its current facility opened August, 2008. With more than 100,000 square feet, the school houses the largest law library in western North Carolina.

Central Piedmont Community College

With six campuses across Mecklenburg County, CPCC offers GED Classes, two-year Associates Degrees, and training in more than 100 technical specialties. The CPCC Institute of Entrepreneurship helps area residents and students establish or grow small businesses by providing training, counseling and resources.

BELMONT ABBEY

A private liberal arts school founded in 1876, Belmont Abbey is guided by the Catholic Intellectual Heritage and inspired by 1500-year-old Benedictine monastic traditions. The school, affiliated with the Roman Catholic Church and Order of Saint Benedict, accommodates approximately 1,500 undergraduate students.

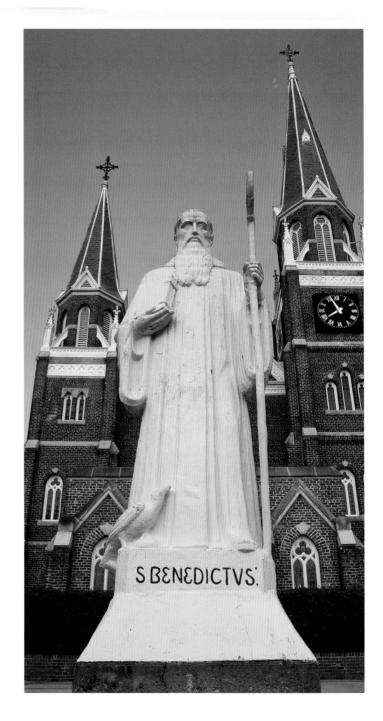

WINGATE UNIVERSITY

Wingate University, founded in 1896, is a private four-year institution offering 34 undergraduate degrees with majors in the arts, science, business, education, fine arts, music, and sports science. The 400-acre campus is about 30 miles from Charlotte in Wingate, NC. The University supports 19 NCAA Division II sports teams and has more than 2,000 students.

WINTHROP UNIVERSITY

Founded in 1886, Winthrop offers 37 undergraduate and 24 graduate degrees through its Colleges of Arts and Sciences, Business Administration, Education, and Performing Arts. Winthrop's 100-acre central campus and 325-acre athletic and recreational facilities are located in Rock Hill, SC just across the state line.

51

WORK

Banking and Beyond

From banking to manufacturing, from white collar to green collar, Charlotteans are on the job. Always the crossroads of the New South, Charlotte grew to new heights, literally and figuratively, during the last two decades of the twentieth century when the city gained international recognition as a banking hub.

As the second largest financial services center in the country, the city's skyline is punctuated by bank towers. Bank of America's 2008 acquisition of Merrill Lynch made it the world's largest wealth manager and a major player in the investment banking industry. Bank of America, headquartered in the Queen City, is just one of hundreds of financial service companies, such as Wells Fargo, CitiFinancial, TIAA-CREF, Fiserv and Transamerica Reinsurance that have large operational and customer service centers in the region

Location, Location, Location!

Charlotte's strategic geographical location is within two hours flying time of 50% of the U.S. population and at the crossroads of major transportation routes I-77, I-85 and I-40 which have helped make Charlotte a favored business destination.

The region's mild year round climate, international airport, affordable cost of living, and skilled, educated work force are among the key reasons many companies have chosen to build or relocate their facilities here.

- *Charlotte is the country's fifth largest urban region.*

- *Home to eight Fortune 500 companies:*
 BANK OF AMERICA, SPX, GOODRICH, DUKE ENERGY, NUCOR, LOWES COMPANIES, FAMILY DOLLAR STORES INC, AND SONIC AUTOMOTIVE

- *In addition, 325 of Fortune 500 companies have facilities in Mecklenburg County, which makes the Charlotte area seventh in the country for Fortune 500 companies.*

- *Charlotte is an official foreign trade zone allowing goods to be brought in duty free.*

- *850 foreign-owned companies, representing 50 countries operate in the Charlotte regional area.*

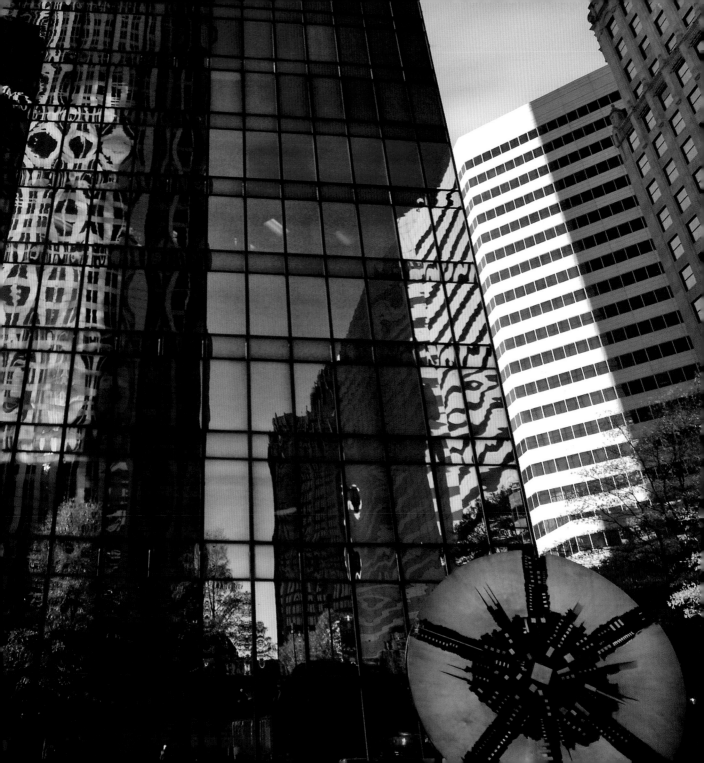

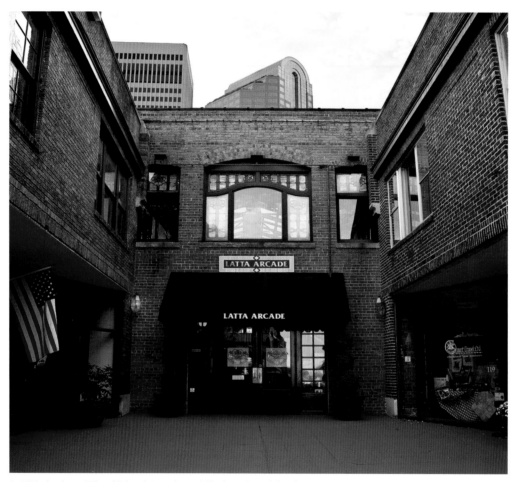

In 1890, developer Edward Dilworth Latta formed Charlotte Consolidated Construction Company, eventually headquartered in the now historic Latta Arcade on Tryon Street. The Arcade was designed in 1914 by architect William H. Peeps.

Latta renamed 1,000 acres of "rural" land south of the city, Dilworth. This early suburb was one of Charlotte's premier neighborhoods at the turn of the century when Victorian architecture was at the height of fashion. Today, the original section of Dilworth includes well-preserved pre-1910 upper-class residences, and also Charlotte's pioneer "suburban industrial park."

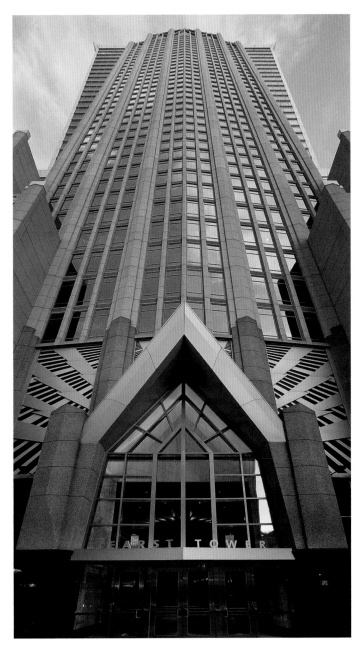

The 46-story Hearst Tower houses Bank of America's extensive art collection.

An Area for High Growth Industries

According to Ronnie Bryant, president and CEO of the Charlotte Regional Partnership, Charlotte enjoys other high-growth industries in addition to financial services. These include: defense and aerospace, health and life sciences, and energy.

More than 1,000 defense contractors in the region have been awarded over $3.7 billion since 2000. Local universities supply research and development expertise while area companies manufacture aerospace components and advanced materials for military applications. Both Goodrich Corporation and General Dynamics Armament and Technical Products call Charlotte home.

The region's health and life sciences sector boasts biomedical device manufacturing as its cornerstone. Brainchild of billionaire David Murdock, The North Carolina Research Institute in Kannapolis, built on the former Cannon Mills site, is expected to grow into a $1.5 billion biotech center. The North Carolina Research Institute in Kannapolis combines the intellect of nine research universities to focus on the development of world-class research and expertise.

UNC Charlotte's Energy Production Infrastructure Center (EPIC), Duke Energy and the Electric Power Research Institute's R&D are among the resources for the region's burgeoning energy industry. Companies, Bryant says, are making and saving energy; they're using, transporting and storing it; even researching more about it, making Charlotte an energy capital. The region has a cluster of nuclear industry expertise and engineering talent, and is rapidly gaining recognition in the solar, biofuel and wind energy sectors.

LEFT: *Raymond Kaskey's Commerce sculpture on Trade & Tryon;* RIGHT: *With 16 affiliates and 1,309 banking locations in 12 states, Fifth Third Bancorp operates its North Carolina headquarters in uptown Charlotte. General Dynamics and Goodrich also call Charlotte home.*

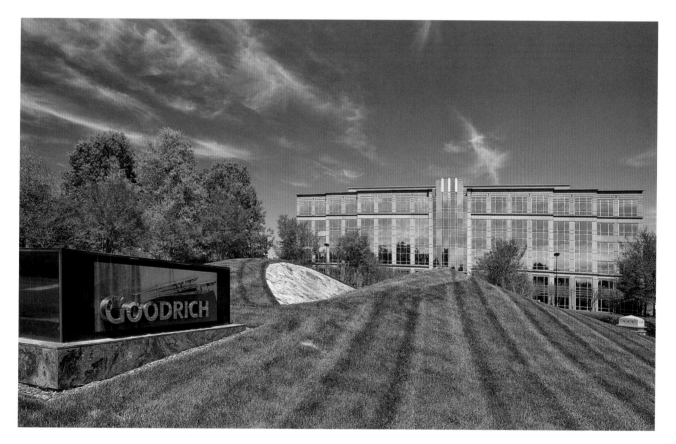

Financial Services

- Charlotte is the second largest U.S. banking center with more than $3.3 trillion in financial assets.

- The city is home to 20 banks and one U.S. Federal Reserve Bank. Together, they employ nearly 100,000 individuals.

- The area's largest banks include Bank of America's headquarters, Wells Fargo's Eastern Regional Headquarters, BB&T Corporation, SunTrust Bank, RBC Bank, First Citizens Bancshare, and Fifth Third Bancorp.

- More than 250 financial service companies employ an additional 60,000. These companies include: CitiFinancial, G.E.Capital, TIAA-CREF, TransAmerica Reinsurance, AmeriCredit, and the College Retirement Equities Fund.

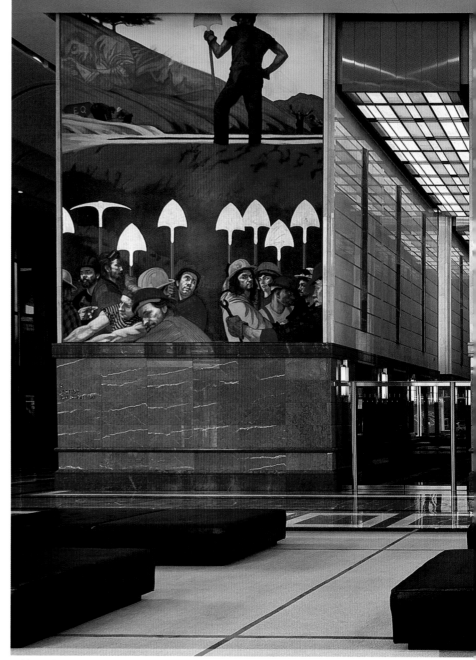

Lobby in the Bank of America Headquarters with frescos by Ben Long

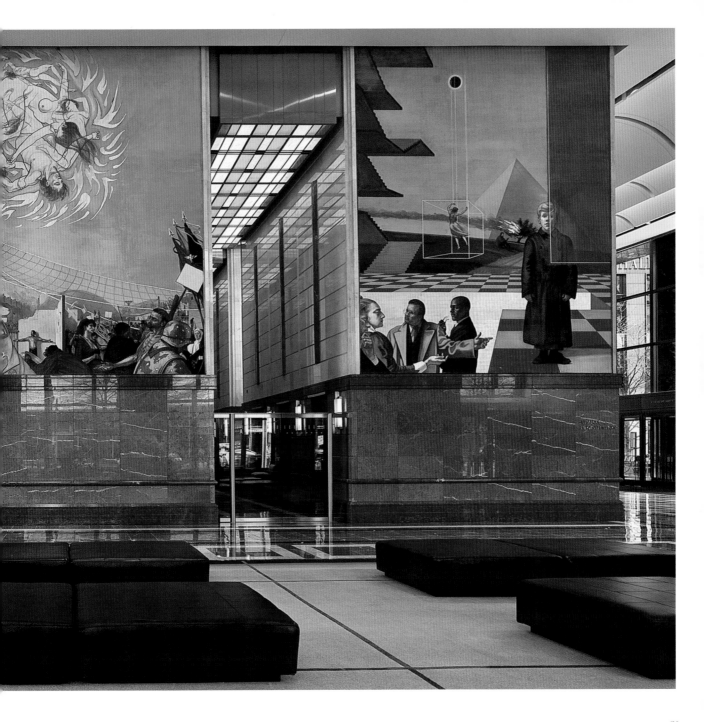

In 1983, Hugh McColl became North Carolina National Bank's chief executive officer, taking charge just as the business began significant growth. During his 18-year tenure as CEO, NCNB moved across state lines, time zones, and regions to become one of the three largest banks in the nation. In the process, the company changed names twice, becoming NationsBank in 1991, and then, in 1998, Bank of America. Devoted to the city of Charlotte, McColl's many contributions have helped the Queen City become the South's most powerful financial center—and one of the most cultured, dynamic and accessible cities in the nation.

Today, Bank of America is the largest bank holding company in the United States, by assets, and the second largest bank by market capitalization. It serves clients in more than 150 countries and has a relationship with 99% of the U.S. Fortune 500 companies and 83% of the Fortune Global 500.

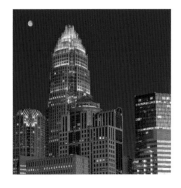

Wachovia, formed by the 2001 merger of First Union Corporation and the former Wachovia Corporation, made its headquarters in Charlotte. (First Union began in Charlotte at the turn of the century with a location in the Buford Hotel on Tryon Street.)

In December, 2008 Wachovia merged with Wells Fargo Corporation, creating the fourth largest U.S. financial institution with $1.2 trillion in assets and nearly 300,000 employees. Charlotte remains Wachovia/Wells Fargo's Eastern Regional Headquarters.

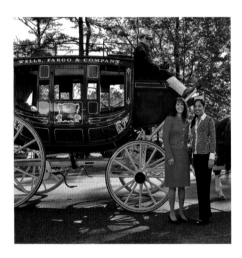

At Charlotte's KIPP Academy, Wells Fargo executive Laura Schulte and Miss America volunteer their time to help kids improve their reading skills.

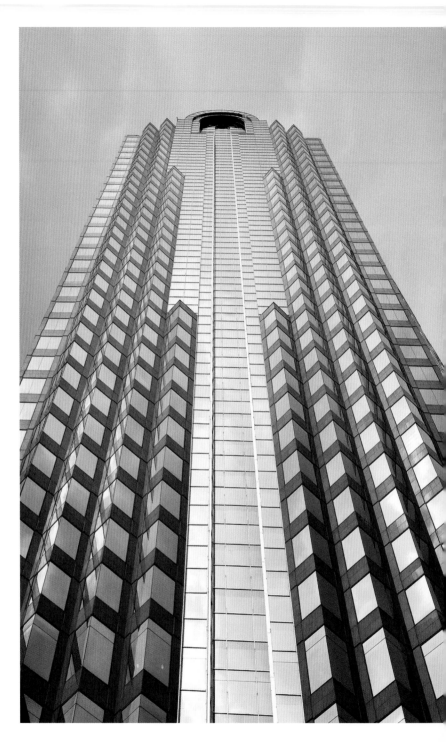

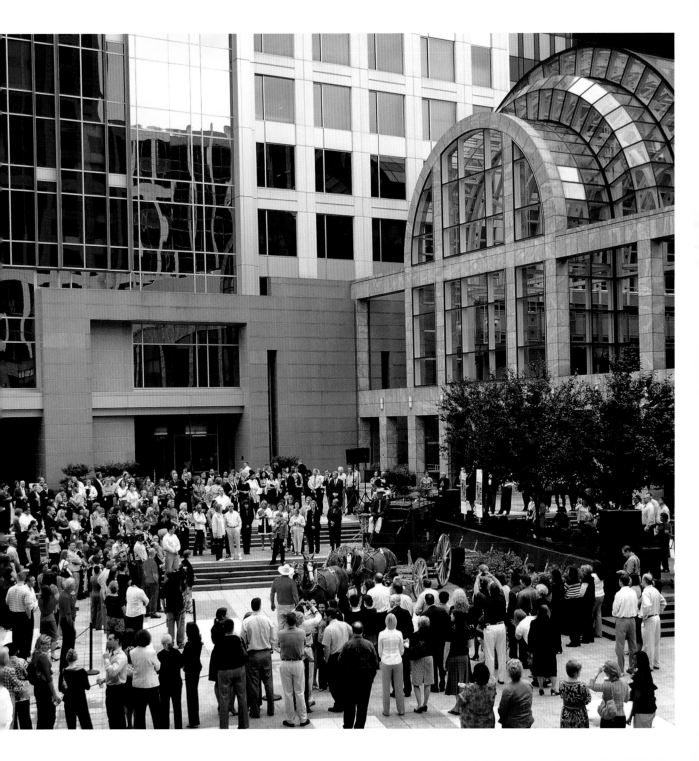

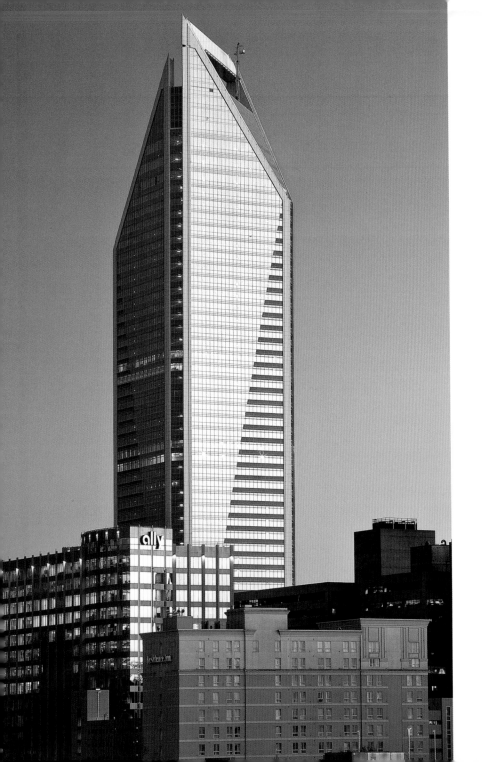

Duke Energy was originally founded by brothers Dr. Walker Gill Wylie and Dr. Robert H. Wylie who realized the value of harnessing the power of the Catawba River. The two convinced another pair of brothers, James Buchanan Duke and Benjamin Duke to invest in a series of hydroelectric power plants along the river. The company was incorporated as Southern Power Company in 1905 with Dr. Walker Gill Wylie as president and Benjamin Duke, first vice-president. James Duke later served as president from 1910-1924. The company was renamed Duke Power, and subsequently Duke Energy. It supplies energy to four million customers with 35,000 megawatts of electrical generating capacity in the Carolinas. Duke Energy is a leader in nuclear power and alternative power sources such as solar and wind power.

OPPOSITE, TOP: Duke Energy's 5,100 solar panels on the roof of a manufacturing building near Charlotte, NC, cleanly generate 1.2-megawatts of electricity. BOTTOM: McGuire Nuclear Station on Lake Norman.

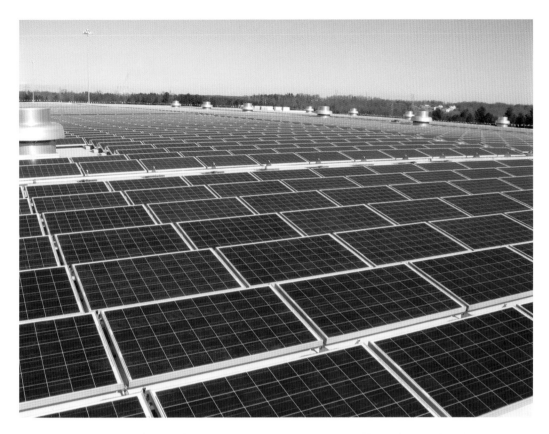

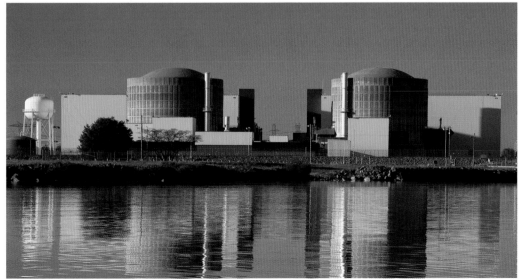

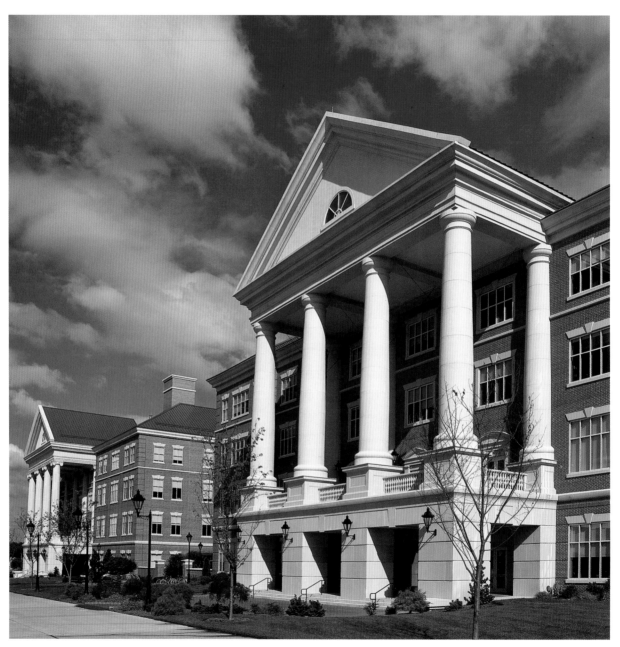

ABOVE: *North Carolina Research Campus in Kannapolis, NC.* FACING PAGE: *NC State Lab and David H. Murdock Core Lab. Both labs were designed and manufactured by Kewaunee Scientific Corporation headquartered in Statesville, NC. (Kewaunee designs, manufactures, and installs products for the laboratory furniture market.)*

The Best and the Brightest

In 2005, David H. Murdock, owner of Castle Cooke, Inc. and Dole Food Company, along with Molly Corbett Broad, then President of the University of North Carolina system, announced the creation of the North Carolina Research Campus, a scientific and economic revitalization project that encompasses the 350-acre site of the former Cannon Mills plant and the downtown area of Kannapolis, North Carolina.

Federal, state, and regional government officials joined in announcing plans for what continues to be the largest economic development project in the state of North Carolina. The campus is home to seven UNC universities, Duke University and Rowan Cabarrus Community College Biotechnology Training Center, as well as a growing number of corporate partners. This collaborative brain trust is focused on transforming science at the intersection of human health, nutrition and agriculture while using cutting edge science and technology platforms.

In North Carolina State University's Plants for Human Health Institute, scientists are developing a new generation of fruits and vegetables with desired traits to improve human health. At the David H. Murdock Core Laboratory, the latest scientific instrumentation in the western hemisphere is grouped under one roof to provide tools to drive innovation and discovery to alleviate diseases that plague mankind. Duke University received a $35 million gift from Murdock to begin a longitudinal genetic study to identify genomic linkages within and across disease and disorders such as hepatitis, cardiovascular disease, obesity, cancer and osteoarthritis. The $1.5 billion complex brings together an enclave of the world's best and brightest scientists with the world's best scientific instrumentation.

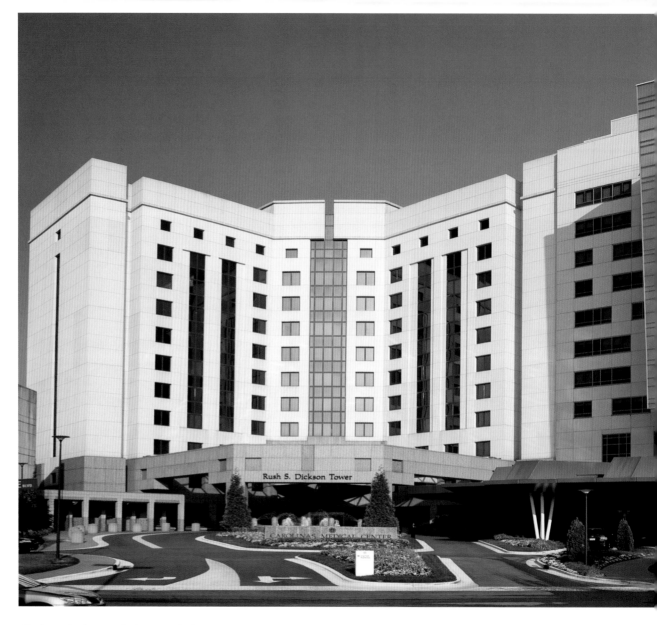

Charlotte's Carolina's Medical Center is the largest trauma center between Washington, D.C. and Atlanta. As the nation's third largest public healthcare system, Carolinas HealthCare System has nearly three dozen facilities throughout the region that provide outstanding patient care. Hundreds of physicians, nurses, and other medical professionals live and work in Mecklenburg and surrounding counties.

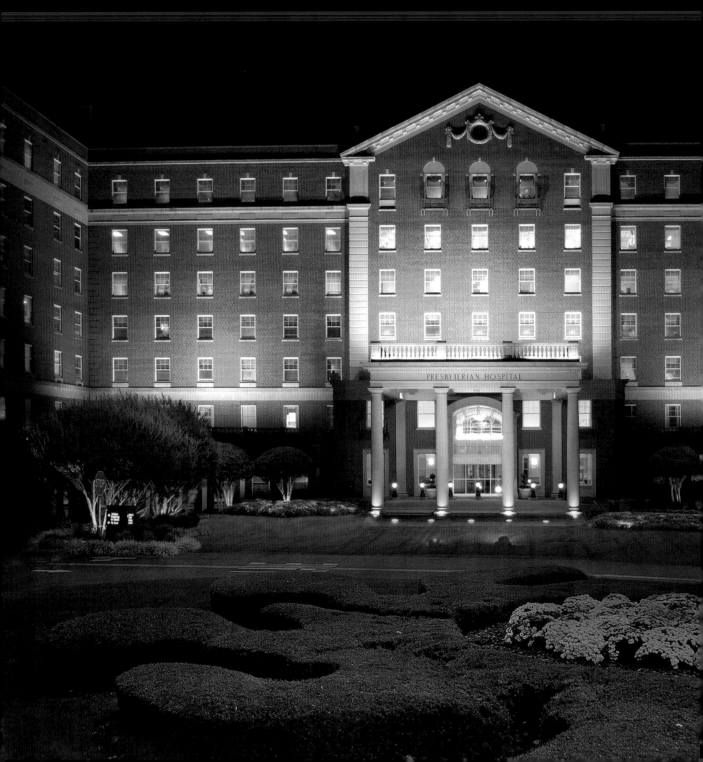

Presbyterian Hospital, a private nonprofit medical center, is the flagship hospital for Presbyterian Healthcare. Founded in 1903, the hospital began as a 20-bed facility and grew to be one of the largest healthcare entities in the Carolinas. Its facilities include: Hemby Children's Hospital, Presbyterian Cancer Center, Presbyterian Orthopaedic Hospital, Buddy Kemp Cancer Support Center, Presbyterian Cardiovascular Institute, and Presbyterian Novant Heart Wellness.

"When I first arrived in Charlotte in 1965 I saw it as a great urban laboratory with a sense of dynamism in the air. The city was moving! I saw opportunities for urban housing and retail and realized I could be part of something that would make a difference. I recognized that I could use my knowledge and training in an effective way and began to envision uptown Charlotte as the living room of the region. My first city architectural commission was the development of the Belmont Regional Center.

Uptown Charlotte has evolved with many successes and some failures. With the help of Charlotte's Uptown Development Corporation, the predecessors to Charlotte Center City Partners, we have been successful in involving many business leaders who were serious about developing a future master plan for the city.

Today, I live in Charlotte's Fourth Ward and I love to walk to Trade and Tryon with my out-of-town guests who are always fascinated by the level of activity at 10 P.M. on a Friday or Saturday when the streets are filled with people. Charlotte is a small town that has grown big, offering a quality of life found in a close knit community but surrounded by the advantages of a big city."

—HARVEY GANTT
former Mayor of Charlotte

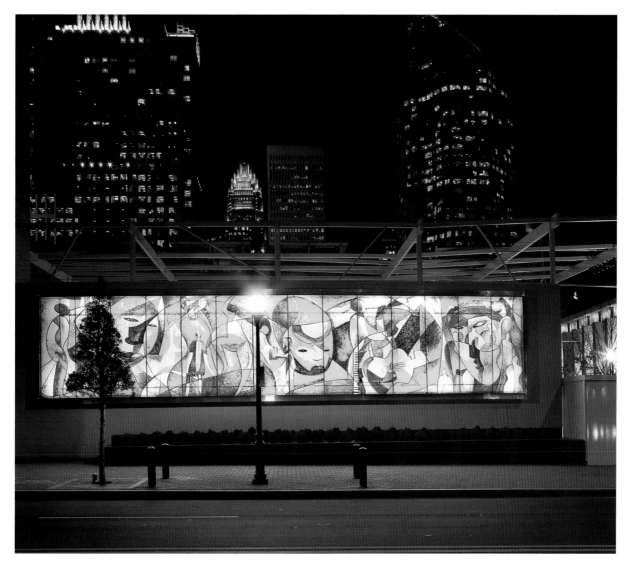

Harvey Gantt has been a civil rights pioneer and long time leader in the African American community. During his tenure as mayor, the city's first African American Cultural Center was opened in 1986.

In 2010, the City of Charlotte honored Gantt's contributions to the city by naming a new, four-story African American cultural center in his honor. The Harvey B. Gantt Center for African-American Arts and Culture features a 7,000 square foot art gallery and three exhibit halls.

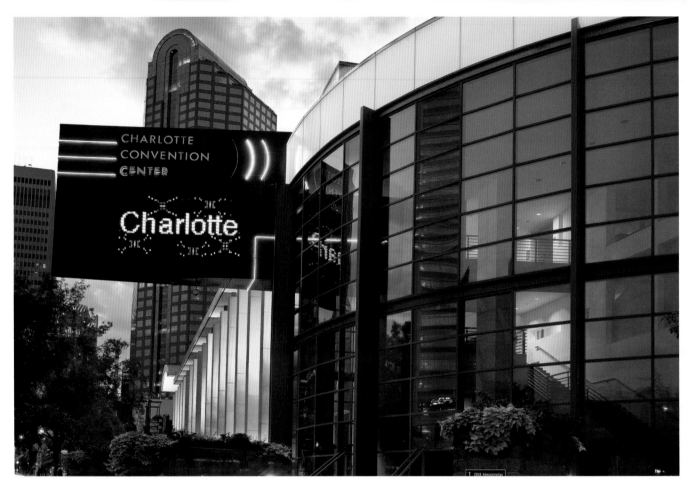

On an annual basis, the Charlotte Regional Visitors Authority facilities host more than 600 events attended by approximately two million residents and visitors. Charlotte's city owned and managed convention and exhibition facilities generate millions of dollars from conventions, trade shows and conferences.

The city also manages the 20,000-seat Time Warner Cable Arena, the 9,600-seat Bojangles Coliseum, and the 2,600-seat Ovens Auditorium. In addition, the city owns the 72,500-seat Bank of America Stadium, and the NASCAR Hall of Fame.

Millions flock to see the latest and greatest in transportation, cuisine, fashion and technology. The Charlotte Convention Center, with its 0,000 square foot exhibition hall and 44,000 square foot ballroom, hosts events that range from public shows and exhibitions to national conventions and trade shows.

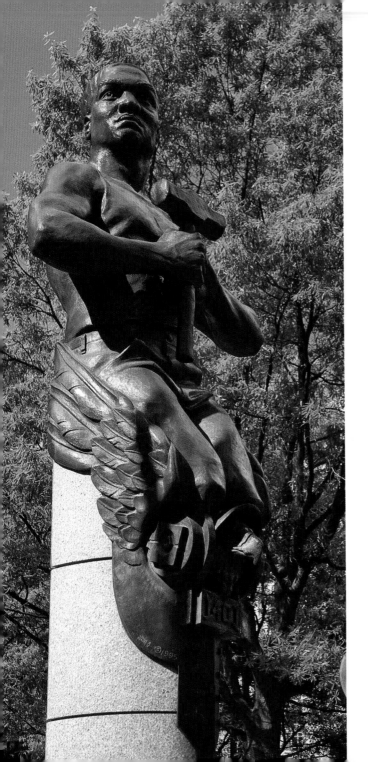

Charlotte Douglas International Airport is ranked as the nation's ninth busiest airport and is a hub for U.S. Airways with 655 daily flights, 134 direct non-stop flights and international service to Frankfurt, Munich, London, Paris, Montreal, Toronto, Rome, Rio de Janeiro, Mexico City, Cancun, Cozumel, Antigua, Aruba, Barbados and the Bahamas.

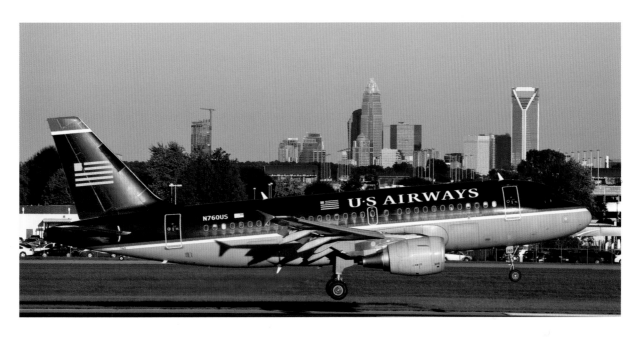

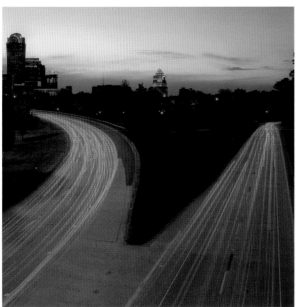

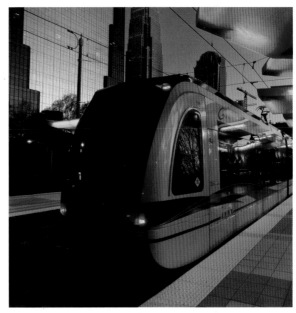

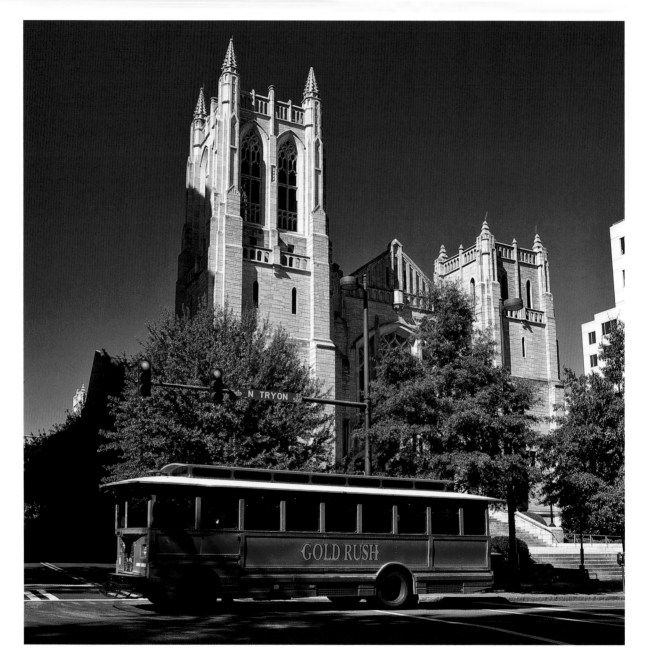

ABOVE: *The Gold Rush, a trolley-themed bus transports workers around town.* FACING PAGE, TOP: *Charlotte Mecklenburg police officers Anthony Dillingham and Kevin Krauz on patrol. Charlotte Mecklenburg Police Department consists of approximately 1,700 sworn law enforcement officers, 550 civilian personnel and more than 400 volunteers. Barbering Charlotte businessmen for more than 30 years, Gene Buchan of Gene's Master Cuts has become an institution.* BOTTOM: *The Laurel Avenue Fire Station, Engine Company #6, makes a beautiful architectural statement in stone and brick.*

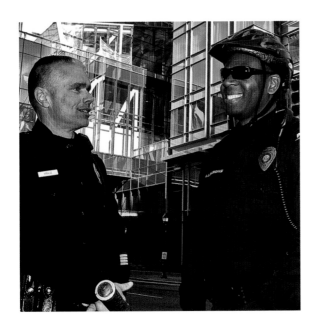

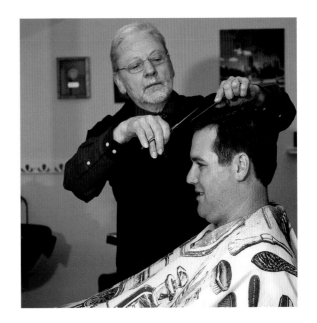

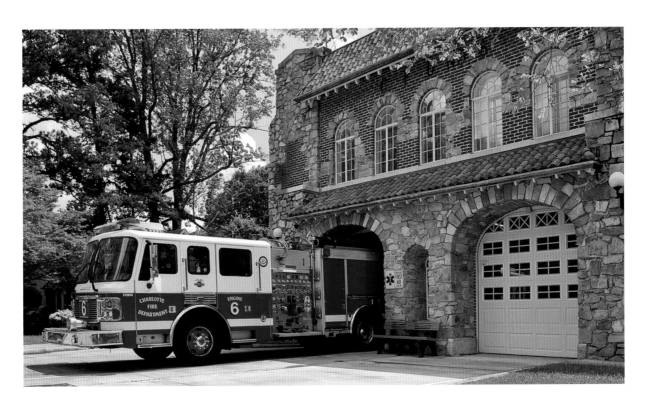

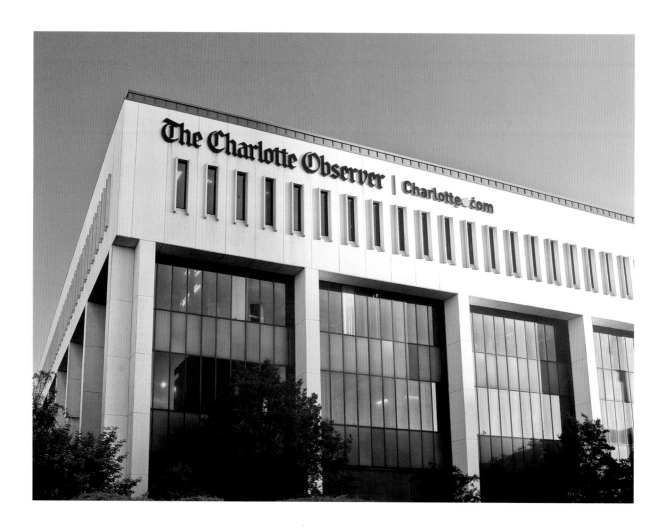

The first *Charlotte Daily Chronicle*, predecessor of today's *Charlotte Observer*, rolled off the press March 22, 1886, as a challenge to the publisher of the *Charlotte Daily Observer*, founded in 1869. A year later, the overwhelmed *Observer* folded and in 1892, the *Chronicle* took its name. *The Observer* thrived during the early 20th century and was privately owned until the Knights bought it in 1954 for $7.225 million. In 1974, the Knight and Ridder newspaper corporations merged and the *Charlotte Observer* eventually became the fourth-largest newspaper in the Knight Ridder chain. With McClatchy's purchase of Knight Ridder in 2006, the *Charlotte Observer* became the fifth-largest newspaper in the Mc-Clatchy chain. The paper has won four Pulitzer Prizes.

Ronnie Bryant reports that Charlotte, with its diverse site location, strong crew base, wealth of equipment, stages and support services, is home to commercial, independent film, television series and still photography production. Local video production and distribution, plus external projects, has a nearly half-billion dollar annual economic impact on the regional economy.

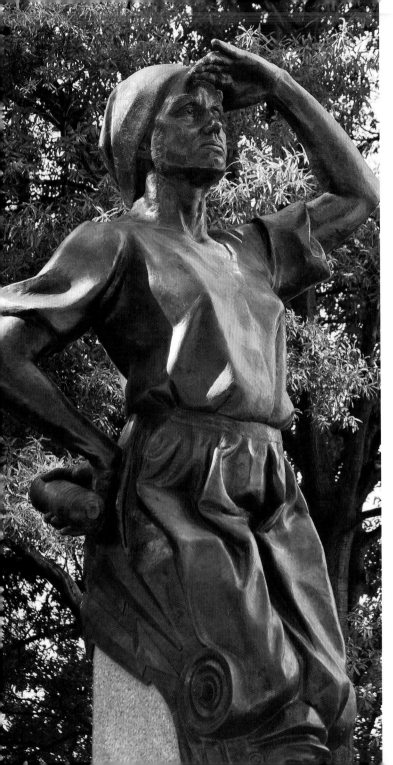

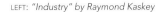

BELK INC

Belk Department Stores were founded in by William Henry Belk and his brother John M. Belk in 1893. For decades, Belk was a mainstay in uptown Charlotte, near Trade and Tryon Streets. Today, the third generation of the family leads the company. Belk Inc. now operates 300 stores in 16 southern states, with $3.5 million in annual revenues, and employs more than 20,000 associates.

LANCE

Nearly a century ago, Phillip Lance and Salem Van Every embarked on a mission to create the perfect sandwich cracker and the Lance brand was born. Now, Lance, Inc. boasts $920 million in annual revenues and employs more than 5,000 nationwide. Lance brands include: Cape Cod Potato Chips, Toms, Stella Doro, Archway, and Lance private brands. In 2010, the company merged with Snyder's of Hanover forming Snyder's-Lance Inc.

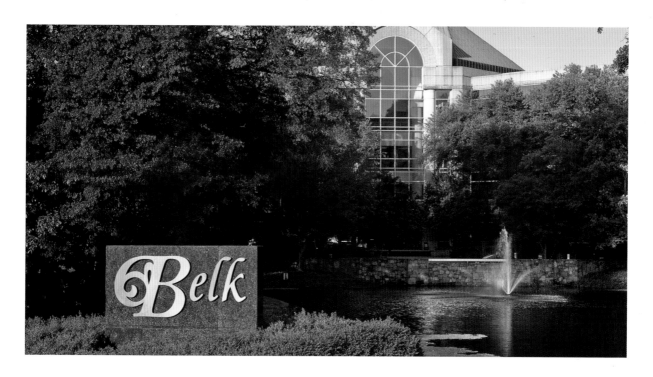

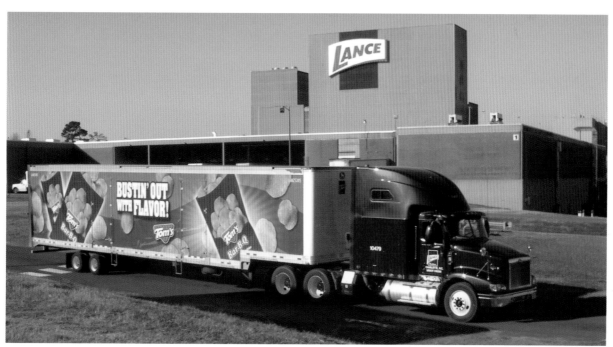

Beginning with one store in 1959 in Charlotte, North Carolina, Family Dollar Stores, Inc. currently operates more than 6,600 stores in 44 states. Family Dollar, a Fortune 500 company, is based in Matthews, North Carolina.

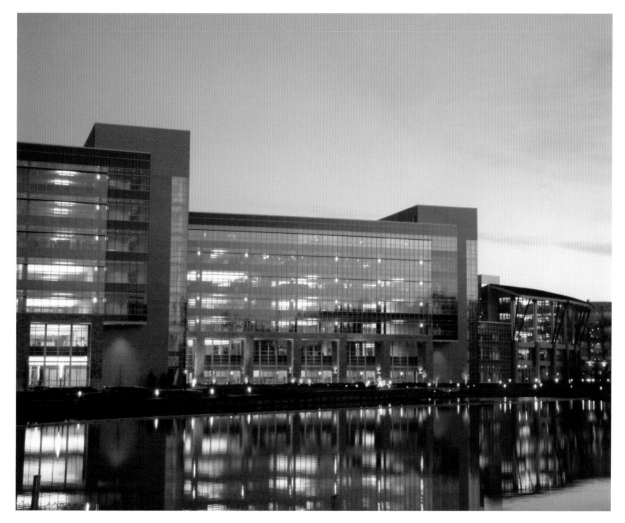

With fiscal year 2009 sales of $47.2 billion, Lowe's Companies, Inc. is a FORTUNE® 50 company that serves approximately 15 million customers a week at more than 1,700 home improvement stores in the United States, Canada and Mexico. Founded in 1946 and based in Mooresville, NC, Lowe's is the second-largest home improvement retailer in the world.

In 2009, Lowe's and the Lowe's Charitable and Educational Foundation together contributed more than $30 million to support community and education projects in the United States, Canada and Mexico. Lowe's also encourages volunteerism through the Lowe's Heroes program, a company-wide employee volunteer initiative.

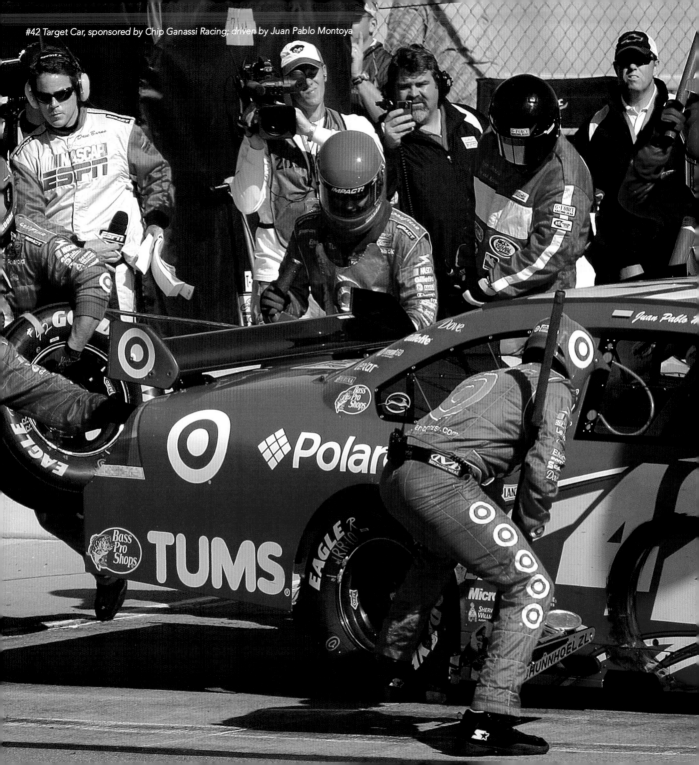

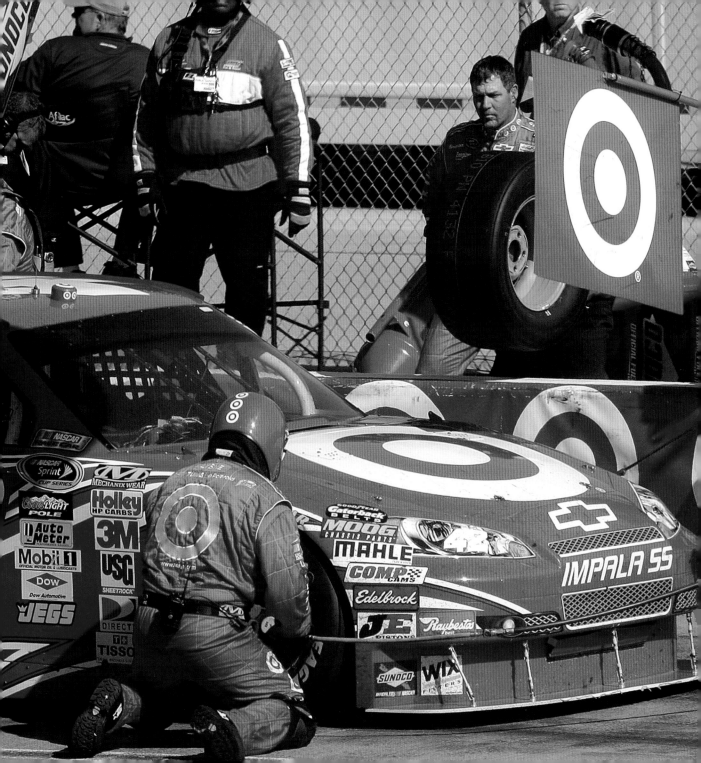

Revving Up the Economy

NASCAR's primary product is what takes place on the track. Everything else—and there's a lot, from car design, physical training and marketing to garage mechanics, college professors and private pilots — supports what takes place on the track.

Culturally and economically, NASCAR (National Association for Stock Car Auto Racing) impacts the Charlotte region to the tune of $4.5 billion each year. NASCAR and NASCAR-related industries employ 27,000 North Carolinians who enjoy average salaries of $71,000.

During the last decade, epic changes in stock car design and engineering, and advances in safety innovations have spurred NASCAR-related industry growth. In addition, competition between the teams has become fierce. Gone are the days when just a dozen teams were contenders; now nearly three times that many teams have a chance at winning. Pit crews once were comprised of shop employees. No longer. Because milliseconds count, teams recruit college athletes for their pit crews. And these crews train rigorously. Courses of study, including a degree program at Belmont Abbey College, prove NASCAR is serious business.

People say NASCAR was born here. And it's true: NASCAR was officially incorporated on February 21st, 1948 and while lots of racing (unofficially) took place across the state and over the state lines, the first official stock car race took place

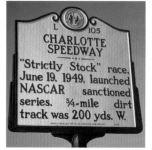

June 19th, 1949 in Charlotte, off Wilkinson Boulevard. Today, Charlotte Motor Speedway hosts more than 300 events each year from which the region receives an estimated $400 million bump.

Winston Kelly, Executive Director of the NASCAR Hall of Fame, says these are the reasons the Hall calls Charlotte home. Kelly attended his first race, the Daytona 500, in 1964. Racing was in his blood as his father, Earl Kelly, served as the Public Affairs Director for the Charlotte Motor Speedway. The Kellys have watched the sport grow in popularity. Winston Kelly has worked as a member of the Motor Racing Network broadcast team and as a field reporter for the FoxSports Network. His greatest accomplishment, he says, will be directing the NASCAR Hall of Fame in Charlotte. Kelly projects the Hall will welcome on average some 400,000 visitors each year, further adding to the positive economic impact the sport has on the region.

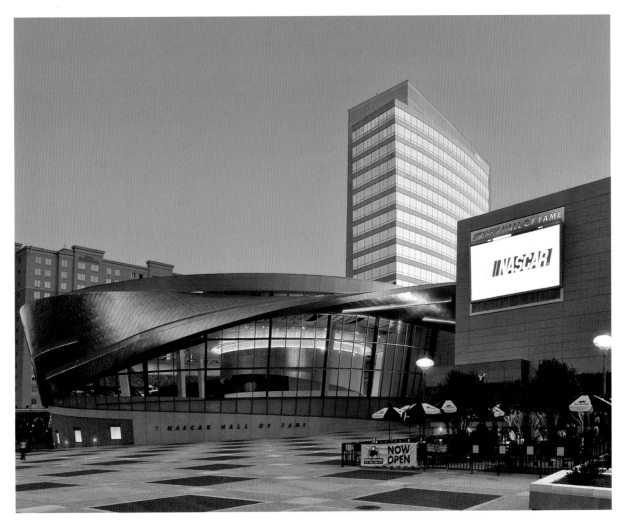

Racing was born in North Carolina. More than 90 percent of NASCAR teams are located within 50 miles of Charlotte, and over 600 businesses, including three wind tunnels that provide precision aerodynamic testing, support the state's $6 billion motorsports industry. The NASCAR Hall of Fame projects attracting 800,000 fans each year.

"Charlotte's beauty, attractions and charm lure visitors from around the world. The spirit of our people brings them back and keeps them here in the Queen City, driving our community's growth, achievements and opportunities.

Many people think of Charlotte as a banking town, and our financial institutions do play a major role, but Charlotte's economy is built on much more. Charlotte is also home to major manufacturing, transportation and distribution centers and is a rapidly emerging global energy center. Companies interested in relocating to Charlotte cite three common reasons for finally choosing our city: our workforce; the lower cost of doing business in Charlotte; and Charlotte Douglas International Airport which provides a level of connectivity that few cities our size can offer.

Our growth and positive energy can be attributed to our community's common vision to make Charlotte the best place to live, work and play."

—BOB MORGAN,
President
Charlotte Chamber of Commerce

ABOVE: *Sculpture at Gateway Village*
RIGHT: *"Future" by Raymond Kaskey*

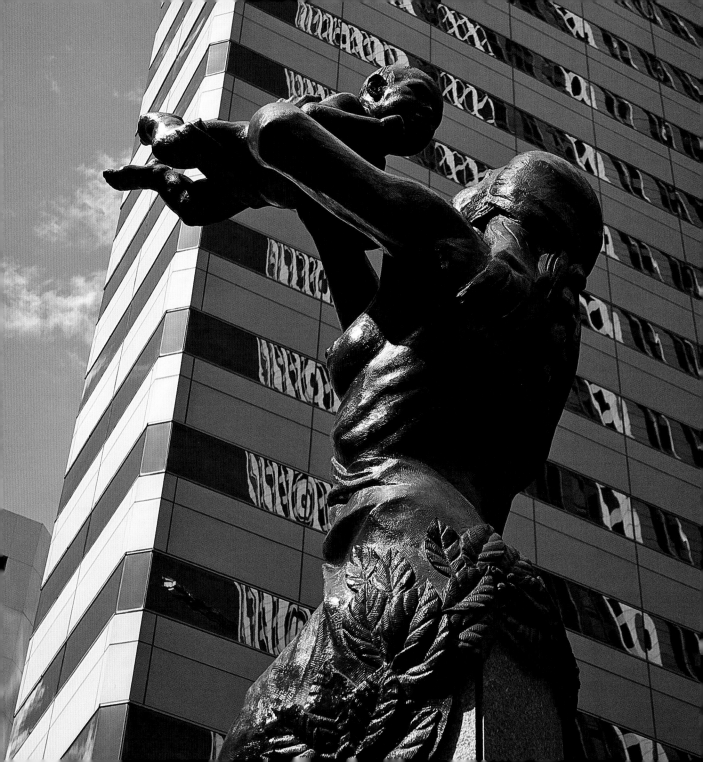

PLAY

When it's time to cut loose, relax, and have fun, Charlotte has something for everyone to enjoy. Community and ethnic festivals, an endless variety of outdoor leisure activities, sporting events, concerts, shows, parades, uptown street fairs — Charlotte can throw a party!

Charlotte's great climate allows people to enjoy year round outdoor activities. We have abundant golf courses, beautiful parks, picture perfect lakes, biking, hiking, boating, fishing, swimming, water skiing, and all levels of recreational sports. Or, you can simply enjoy a lazy day in the sun.

The Mecklenburg County Park and Recreation system includes many parks and preserves, plus pools and greenways for biking, hiking and skating, dog parks, picnic shelters, fishing, kayaking, concerts in the park and numerous family and kid-friendly activities. The U.S. National Whitewater Center provides an incredible facility for whitewater rafting, and is a world class training center for Olympic kayakers.

The Charlotte Arts and Science Council provides support to the Arts, Sciences, history and Charlotte's rich heritage. Charlotteans enjoy and cultivate a wide array of the arts from Classical to contemporary with orchestral music, opera, theater, dance, and touring productions fresh from Broadway. Charlotte is also home to several nationally recognized science history and art museums. The Charlotte music scene offers musical entertainment for everyone at the Blumenthal Performing Arts Center, Verizon Wireless Amphitheater, North Carolina Music Factory, Bojangles Coliseum, Time Warner Cable Arena and a wide variety of local clubs with nightly live entertainment.

Charlotte is a big league sports town with the NFL Carolina Panthers, NBA Charlotte Bobcats, PGA Wells Fargo Championship, Charlotte Checkers hockey, Charlotte Knights Baseball, annual CIAA collegiate basketball tournament, and the Meineke Car Care Bowl.

NASCAR has made Charlotte its year round hometown. From NASCAR's first official stock car race in 1949 at Charlotte Speedway's oval dirt track to the 2010 opening of the NASCAR Hall of Fame, racing is one of the threads that link our past, present and future.

- *Mecklenburg County Park and Recreation's system includes 13 parks, six nature centers and preserves, 25 pools and aquatic centers, and 15 greenways.*

- *Charlotte's annual Arts and Science Council fundraiser is consistently one of the highest (sometimes the highest) per capita united arts fund drive in the country.*

- *90% of NASCAR's race teams are headquartered in the greater Charlotte area.*

- *We host three major NASCAR races: Sprint All-Star Race, Coca Cola 600 in May, and Bank of America 500 in October.*

RIGHT: *Panther sculpture by Todd Andrews*

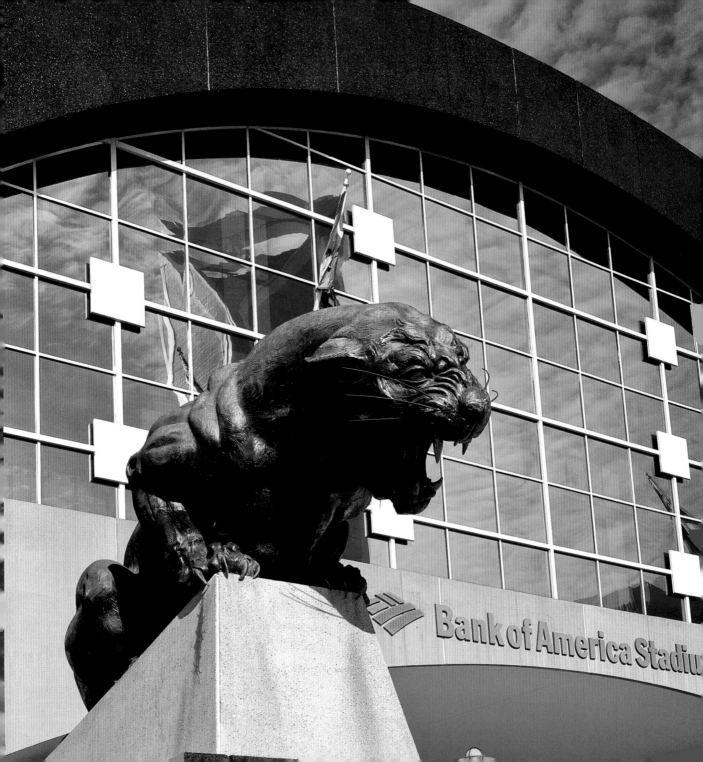

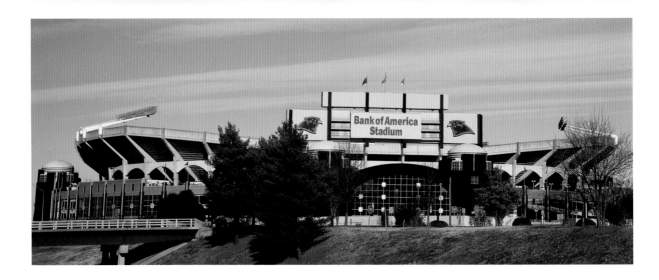

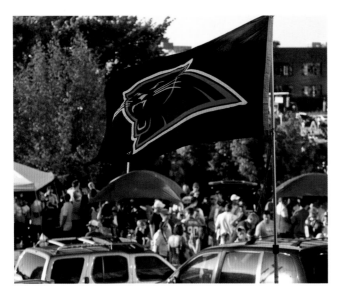

Sports, both professional and amateur, is in the Charlotte region's DNA. With the NFL Carolina Panthers, NBA Charlotte Bobcats, NASCAR Sprint Cup Series, PGA Wells Fargo Championship, AAA Charlotte Knights Baseball and Charlotte Checkers minor league hockey, Charlotte has the sports landscape covered.

CLOCKWISE FROM TOP: *Bank of America Stadium, home to NFL's Carolina Panthers; Charlotteans tailgating before home game; Panthers #1 Super Fan: Catman.*

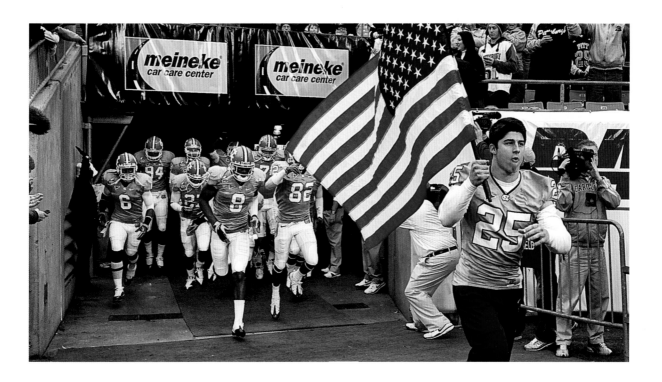

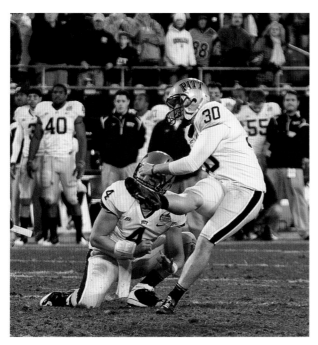

Played at Bank of America Stadium every December, The Meineke Car Care Bowl matches the #3 college team from the Big East Conference with the #5 pick from the Atlantic Coast Conference. In 2009, Pittsburg defeated North Carolina with a last second field goal for a final score of 19-17.

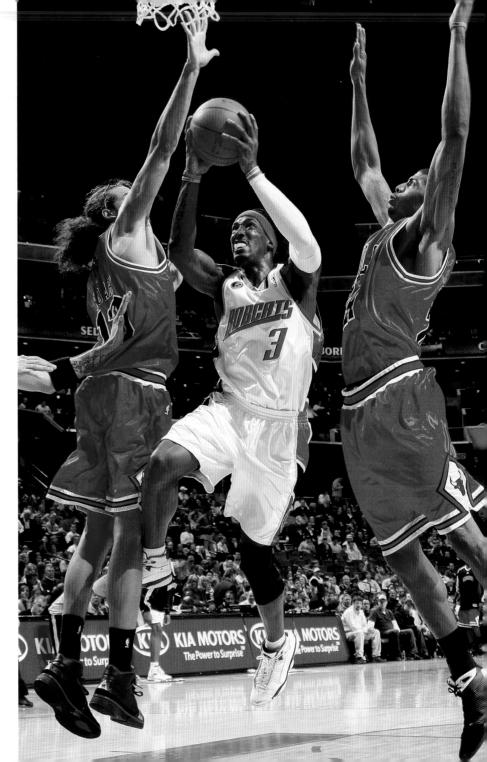

Gerald Wallace, #3 of the Charlotte Bobcats, drives to the basket against Joakim Noah, #13 of the Chicago Bulls, on March 3, 2009 at the Time Warner Cable Arena in Charlotte, North Carolina. (Photo by Kent Smith/NBAE via Getty Images; © 2009 NBAE)

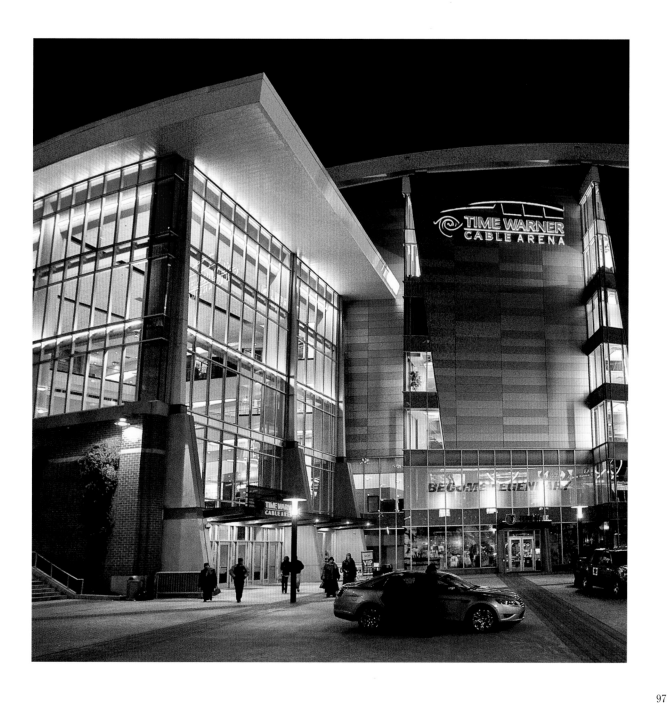

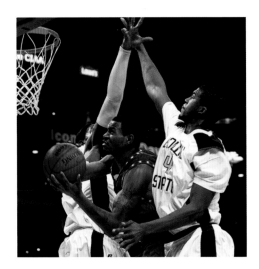

ABOVE: *The CIAA (Central Intercollegiate Athletic Association) holds the third largest U.S. basketball tournament in Charlotte each year, an event that draws more than 175,000 fans. The CIAA showcases men's and women's basketball teams from 11 traditional southern African-American Universities. The tournament provides a weeklong fan fest with activities, music, alumni parties and events.* FACING PAGE: *Sean O'Hair at the PGA Championship at Quail Hollow, May 3, 2009. (Photo by Chris Keane, © 2009)*

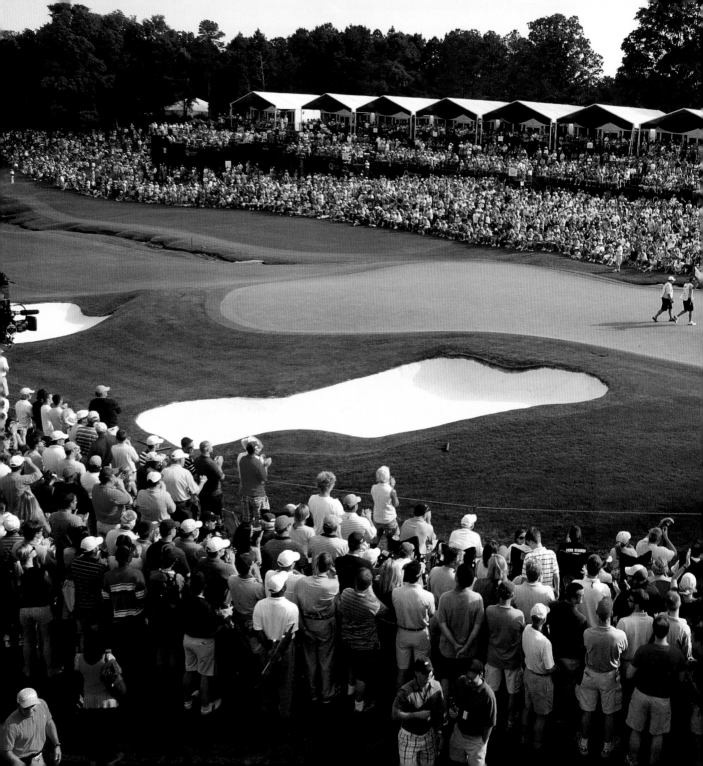

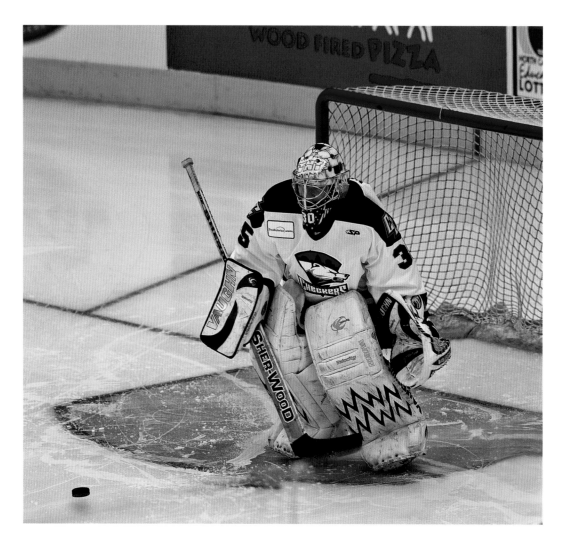

The Charlotte Checkers franchise was founded in 1993 and played from then until 2005 in Bojangles Coliseum. In 2005, they moved to Time Warner Cable Arena. The team set their all time attendance record of 12,398 on February 21, 2009 in a 5-2 win against the Florida Everblades.

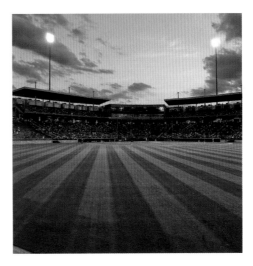

Professional baseball was established in Charlotte as early as 1901 with a team named the Charlotte Hornets. The club lasted in some form until 1973, capturing 11 league titles during its history. Baseball left the Queen City in 1973 until Frances Crockett created the Charlotte O's in 1976. The O's played in the Southern League and served as the Double-A affiliate of the Baltimore Orioles until 1988. George Shinn purchased the O's in 1987 and in 1989, he changed the team's nickname to the Knights through a "Name the Team" contest. A year later, Shinn moved the club to Knights Stadium, a 10,002-seat state-of-the-art facility located in Fort Mill, South Carolina.

"From NASCAR to kids' softball tournaments; from the NFL and NBA, to great high school games; from professional bass fishing and the PGA, to charity road races—this is just a small sampling of the multitude of sports-related opportunities that are available in and around the Queen City."

JEFF BEAVER
Executive Director
Charlotte Regional Sports Commission

Charlotte—Racing's Center

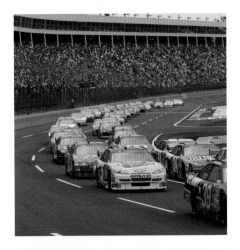

Bruton Smith, CEO of Speedway Motorsports, has been instrumental in shaping NASCAR—both as a sport and as a business. Speedway Motorsports owns and operates eight NASCAR sanctioned race tracks, including the Charlotte Motor Speedway, Charlotte Z-Max Drag Strip and the Charlotte Dirt Track.

Says Smith, "Racing started here in Charlotte as a sport for entertainment and has grown into a major industry that employs seven to eight thousand people with an economic impact of over $5 billion annually to our region." He adds that as the NASCAR Hall of Fame helps racing fans learn more about the history of the sport and legends of the industry, it will also add greatly to area tourism and bring more visitors to the speedway. "Charlotte, being the center of the sport," he says, "will continue to see racing related research and manufacturing facilities contribute to the growth and development of the sport. The future of NASCAR depends on the changes that are initiated as we go forward."

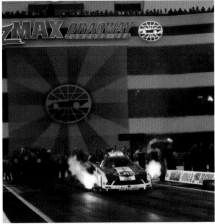

Ninety percent of NASCAR's race teams are headquartered in the greater Charlotte area. Combined, the Charlotte Motor Speedway, Dirt Track and Z-Max Drag Strip annually host more than 300 events. In addition, individuals can experience firsthand the thrill of a 165 mile per hour loop around the track at the NASCAR Driving Experience, Mario Andretti Driving Experience, or Richard Petty Driving Experience.

Charlotte hosts three major races each year: NASCAR's Sprint All-Star Race, the Coca Cola 600 in May, and the Bank of America 500 in October. And the annual Food Lion Speed Street festival provides several days of racing fun with events such as the Pit Crew Challenge.

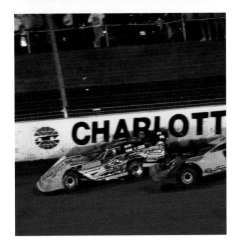

Speedway Motors Sports, the leading marketer and promoter of motorsports activities in the U.S., owns and operates eight of the largest U.S. motor speedways, including the Concord-based Charlotte Motor Speedway, Z-Max Drag Strip and Charlotte Dirt Track. Together, the Concord venues annually host more than 300 racing-related events. (Photos this page courtesy of Harold Hinson.)

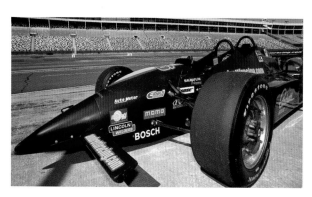

The NASCAR and Mario Andretti Racing Experiences allow you to fulfill your need for speed by driving a real NASCAR or Indy-style race car around the Charlotte Motor Speedway track at speeds of up to 150 mph.

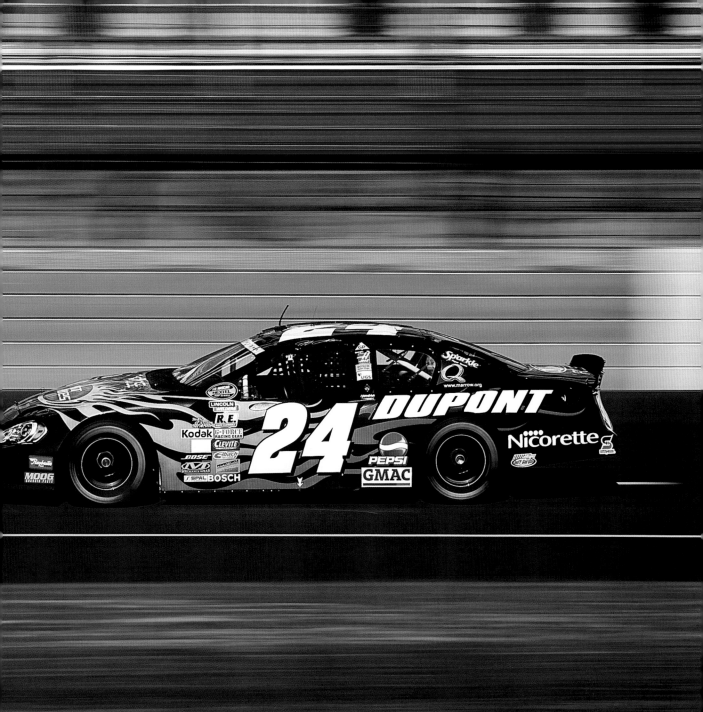

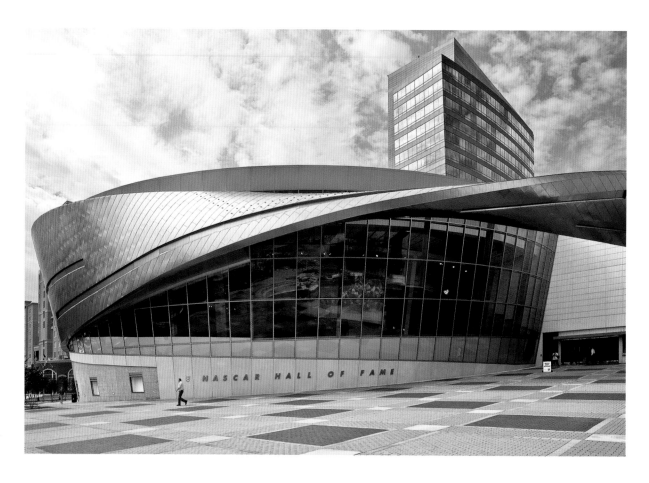

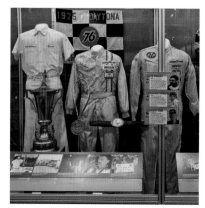

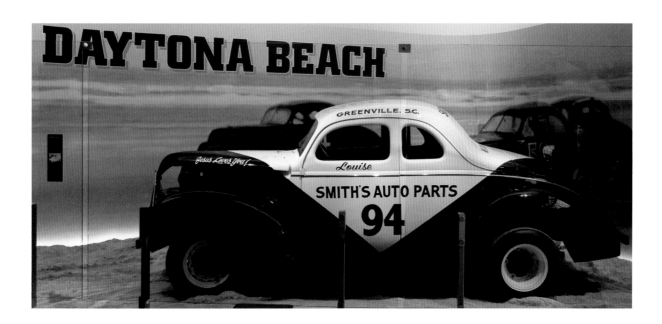

TOP: *1939 Ford, driven by the sport's first female driver, Louise Smith.* BELOW: *Richard Petty's Plymouth Belvedere. In 1967, Petty won a record 27 races, including ten consecutive races in this car.*

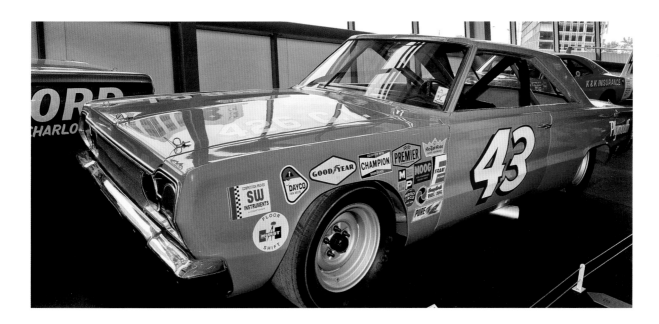

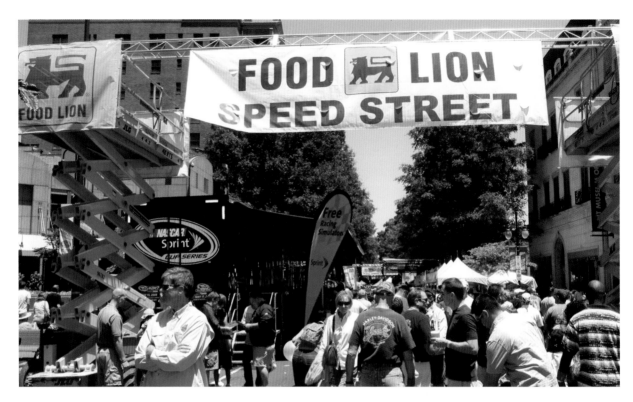

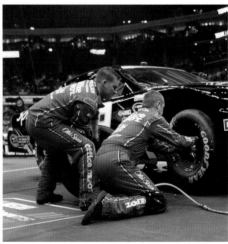

The 2009 Office Depot team competes for the title in the
NASCAR Sprint Cup Craftsman Pit Crew Challenge.
(photo courtesy of HHP/Harold Hinson)

In 2009, the No. 31 Caterpillar Chevrolet team, led by crew chief Scott Miller and pit crew coach Matt Clark, wins the NASCAR Sprint Pit Crew Challenge presented by Craftsman with a time of 22.115 seconds, a new event record, and a $70,675 payout. (photo courtesy of HHP/Harold Hinson)

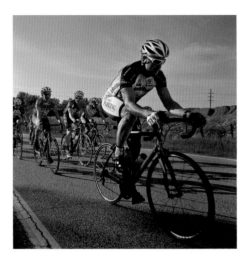

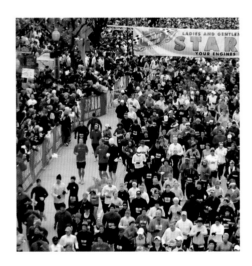

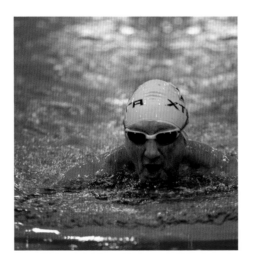

ABOVE, CLOCKWISE FROM TOP LEFT: *Skating on the Green in uptown; Pelaton cyclists; Thunder Road marathoners; swimmer at Mecklenburg Aquatic Center.* FACING PAGE: *Proud fishermen with their stripers; family jet skiing on Lake Norman.*

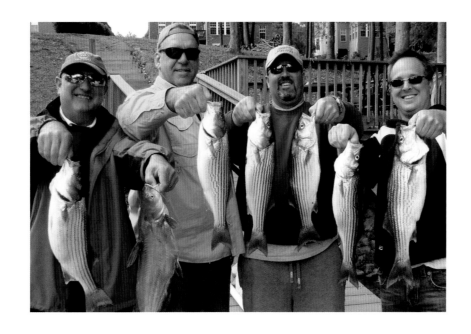

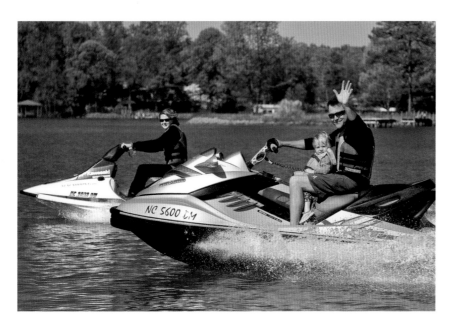

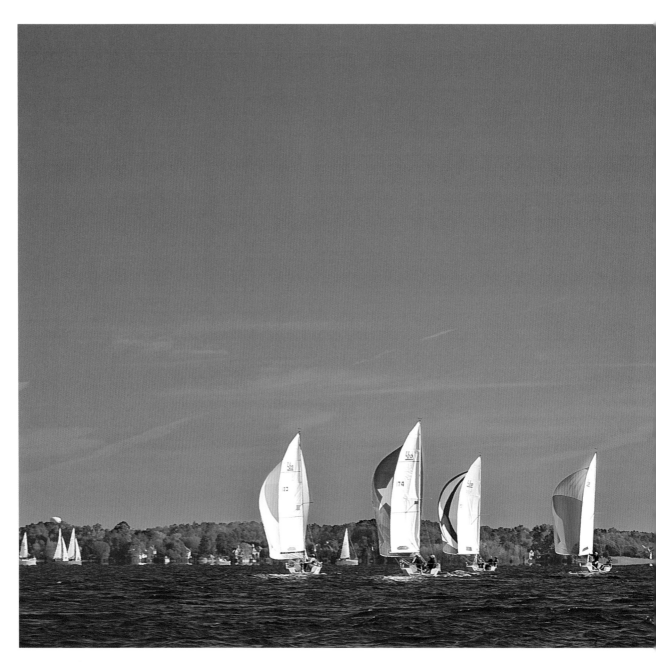

Regatta on Lake Norman

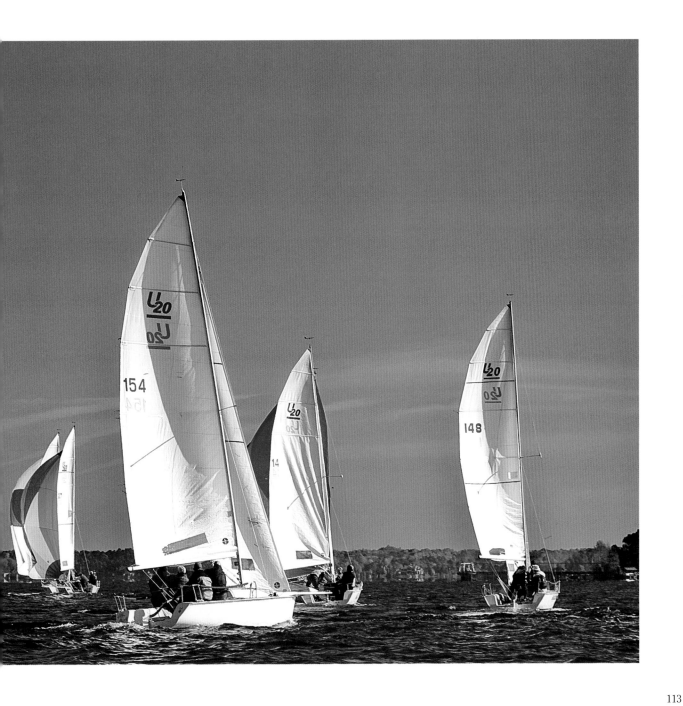

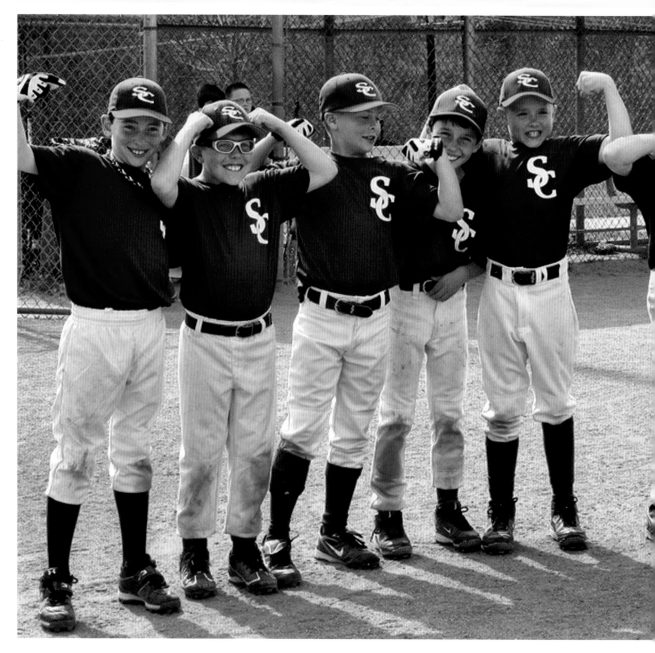

Charlotte area youth can participate in a wide variety of sports from Pop Warner Football, little league, girls and boys soccer leagues, and junior golf, to basket-ball, volleyball and lacrosse. ABOVE: The Steele Creek "Rage" little league team. (Photo courtesy of Carole Williams)

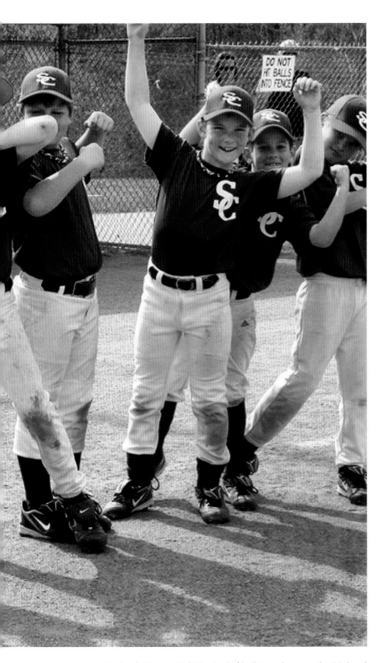

RIGHT: *Indianland Warriors Girls Varsity Softball team has won the 1A South Carolina State championship nine out of the last 13 years.*

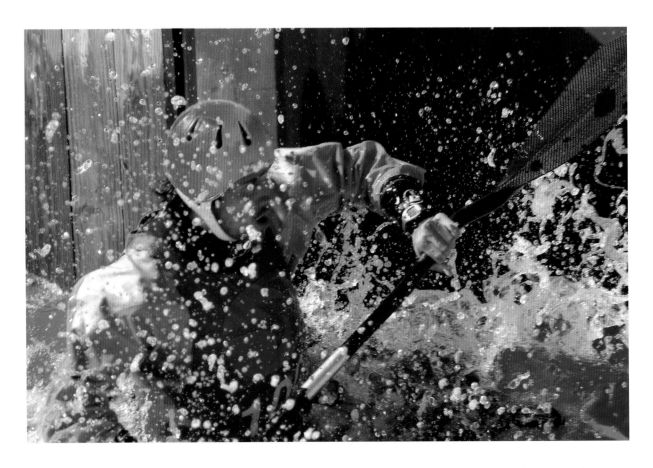

The U.S. National Whitewater Center is the official training site for the U.S. Olympic Canoe and Kayak teams and is available to anyone who wants to take up a paddle and try their hand on the water. In addition to water sports, the Center has a daring rock climbing wall, one of the best zip lines in the southeast, and more than ten miles of mountain bike trails.

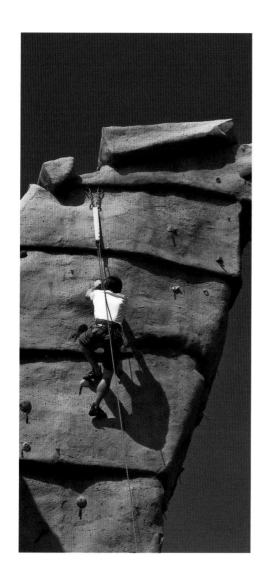

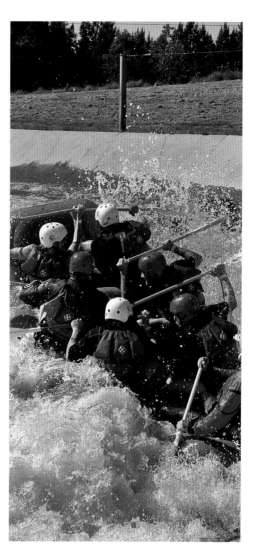

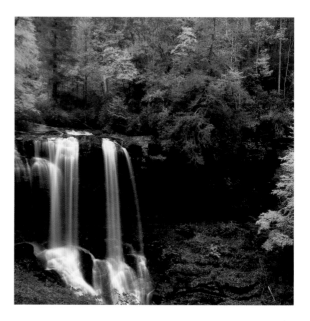

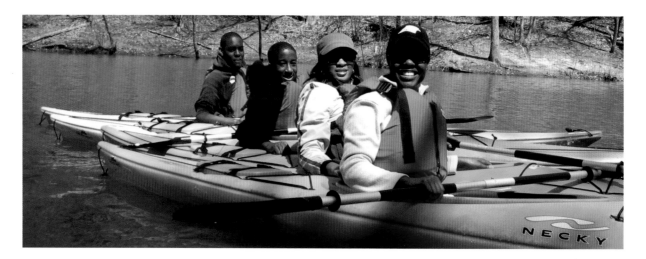

ABOVE: *In the broader region, military history is preserved and displayed at Kings Mountain, North Carolina, and at Cowpens and Brattonsville, South Carolina. Throughout the year, the beauty of the landscape is in abundance along the Blue Ridge Parkway in the North Carolina Mountains.* BELOW: *A family enjoys kayaking on Mountain Island Lake. (Photo courtesy of Neil Elam)* FACING PAGE: *If roller coasters and wild rides are your thing, Carowinds on the North Carolina-South Carolina line will fill your day with fun.*

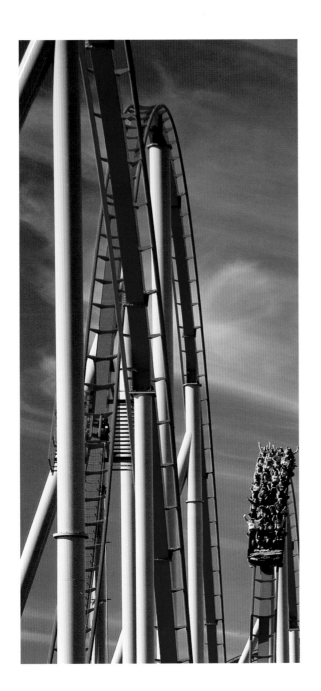

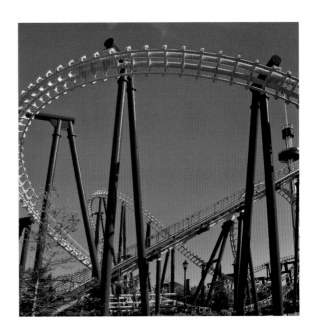

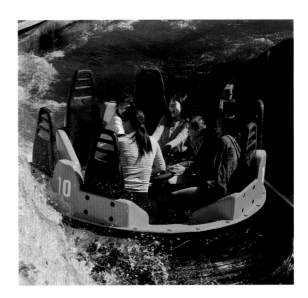

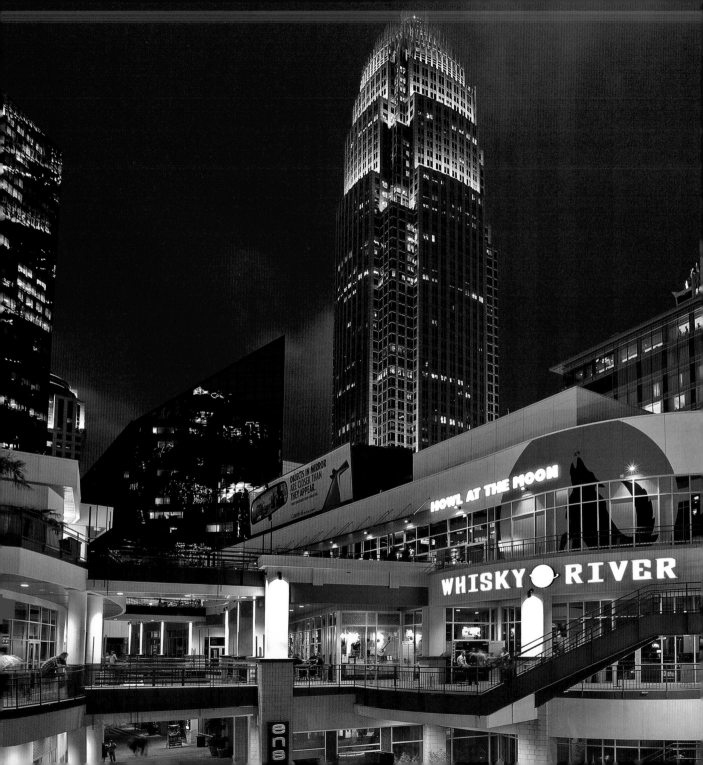

The EpiCentre, on the corner of College and Trade Streets and conveniently connected to the Lynx light rail line, is Charlotte's uptown hub for dining, entertainment and nightlife. The EpiCentre is home to more than three dozen entertainment and dining options and plays host to numerous special events and concerts year round.

With a mix of major destination centers and small unique venues, Charlotte offers a wonderful array of shopping opportunities that can meet any budget or time allocation. Charlotte's SouthPark Mall houses one of the best collections of stores between Washington and Atlanta with national names like Nordstrom, Neiman Marcus and Tiffany as well as regional representatives like Belk and Dillard's. For the more bargain conscious, Concord Mills offers a full array of national outlets at the intersection of I-85 and Bruton Smith Boulevard in Concord just minutes from Charlotte. Charlotte also has many shops that offer a variety of goods from the newest and trendiest to the finest antiques.

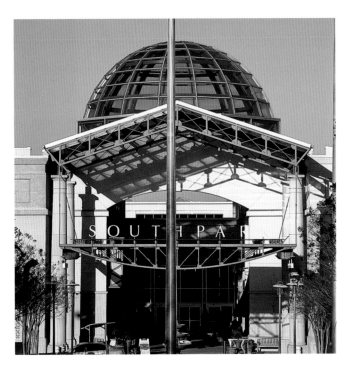

The Charlotte region offers many beautiful, well-preserved historic sites including Historic Brattonsville, a 775-acre Revolutionary war site. Brattonsville features the history of Colonel William Bratton and his family with 30 historical structures dating from 1760 through the 1800s.

The historic Polk homestead, built by the family of the 11th president of the United States, James K. Polk. The site includes the original log cabin, kitchen, and barn.

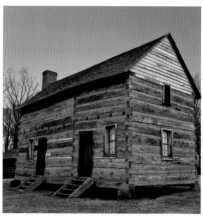

Latta Plantation, a cotton plantation circa 1800 and living history farm, is in northern Mecklenburg County. In 1799, James Latta purchased the 100-acre tract and built a Federal style home there. In 1975, the family deeded the property to Mecklenburg County. In addition to the plantation, visitors can enjoy hiking trails, picnic areas, and the Charlotte Raptor Center. The Raptor Center is dedicated to the conservation of birds of prey through education, research, and rehabilitation of injured and orphaned raptors.

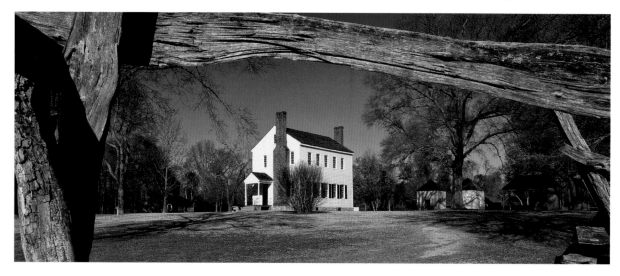

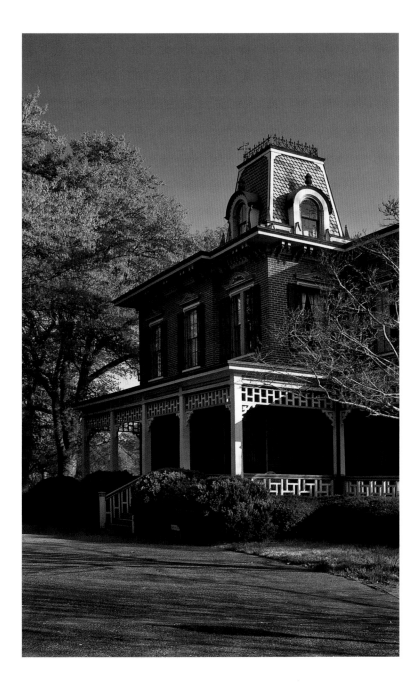

In 1790, John Springs constructed Springfield, a spacious plantation near Fort Mill, South Carolina. Notably, during the final days of the Confederacy, Confederate President Davis and members of his Cabinet spent three days at Springfield as guests of Col. Andrew Baxter Springs, a descendant of John Springs. After the Civil War, in 1886, Leroy Springs established Leroy Springs & Co., a cotton shipping company in Fort Mill, SC. The following year, Col. Samuel Elliott White founded Fort Mill Manufacturing Company.

Fortuitously, Leroy Springs married Capt. White's daughter Grace in 1892, uniting Fort Mills' two most prominent business families.

Fort Mill Manufacturing Company eventually became Springs Mills and later Springs Industries, one of the nation's largest textile manufacturing companies. Springs Industries is now listed on the NYSE with 40 plants and employees in the United States, France and Mexico.

The Founders House (left) was Samuel White's home. After Grace and Leroy's marriage, the neighboring White and Springs Farms became one. Today, Springs Farm and Founders House are used for events and as a guest house for Springs Global visitors.

Evangelist Billy Graham was born in 1918 on a dairy farm in Charlotte. He became an ordained minister in 1935 in the Southern Baptist Convention, studying at Florida Bible Institute and later graduating from Wheaton College in Illinois. He went on to become a preeminent evangelist, in large part due to the astounding success of his Los Angeles Crusade in 1949.

Regularly listed by Gallup as one of the ten most admired men in the world, Graham has counseled U.S. Presidents, European royalty, and world leaders, and has preached to live audiences of more than 215 million people in 185 countries.

In 2003, Graham moved his Billy Graham Evangelistic Association headquarters to Charlotte in conjunction with the opening of the Billy Graham Library. The dedication of these facilities was attended by three U.S. Presidents: Jimmy Carter, George Bush, and Bill Clinton.

126

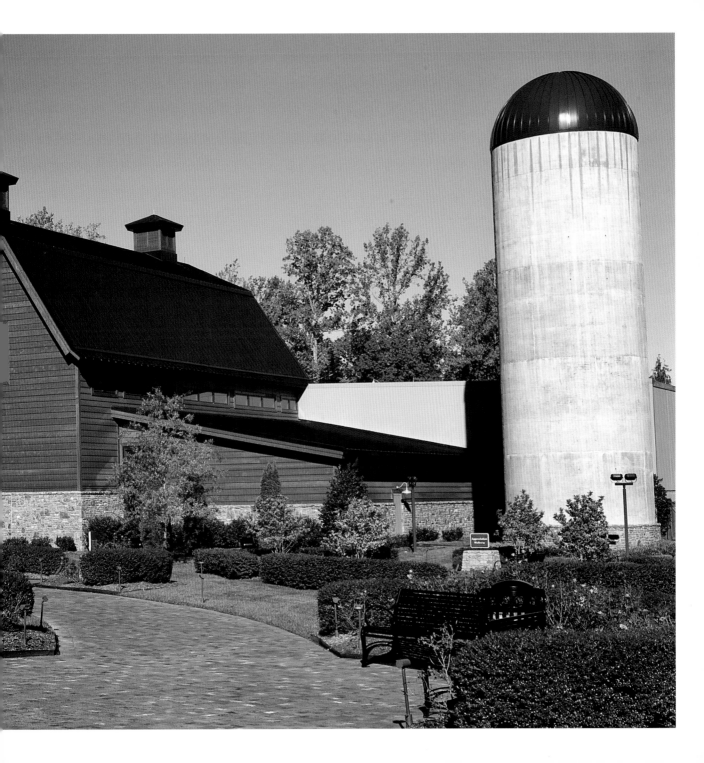

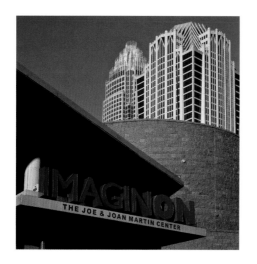

Top: *Imaginon, The Joe and Joan Martin Center, is home to a state-of-the-art children's library geared to preschoolers through teens, as well as Charlotte's Children's Theatre. It is located at 300 East Seventh Street.* Below: *The Mint Museum began as an actual mint when, in 1837, the Charlotte Mint opened for business to process and refine raw gold. In 1931, the building was scheduled to be demolished, but a coalition of private citizens acquired the structure from the U.S. Treasury Department and relocated it a few miles south of downtown. In 1936, it was dedicated as the Mint Museum of Art, the first art museum in North Carolina. In 2010, the Museum moved uptown, to 500 South Tryon Street.*

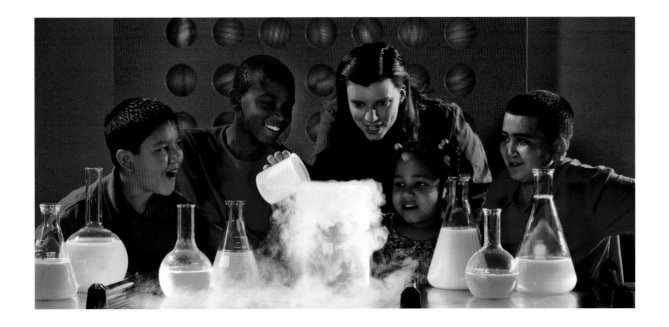

One of the Carolinas most visited attractions and one of the top science museums in the nation, Discovery Place is a science and technology museum with a target audience of families with kids of all ages. Visitors can step into a world where science is brought to life with extraordinary experiences and explosive experiments daily. The museum includes an aquarium, rainforest, and a 3-D theatre, the largest movie-going experience in the Carolinas, the IMAX Dome Theatre. (Photos this page, © Oscar Williams.)

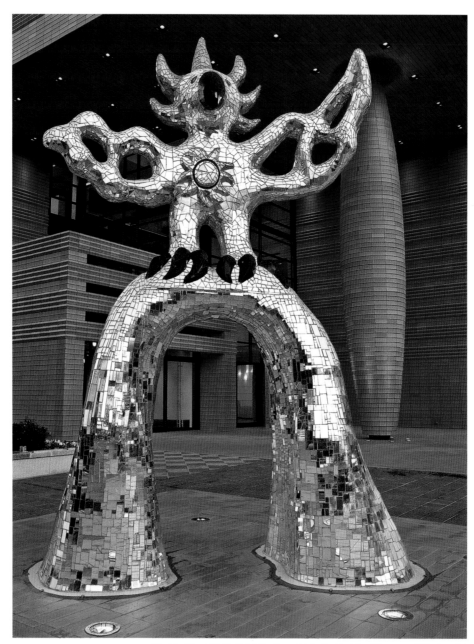

"Firebird" by Niki De Saint Phalle, outside the Bechtler Museum of Modern Art

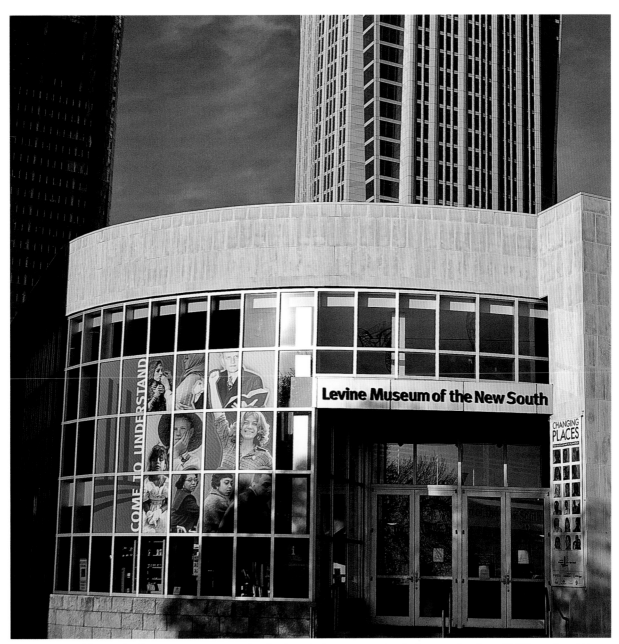

Levine Museum of the New South is an interactive museum housing the nation's most comprehensive interpretation of post-Civil War southern history.

131

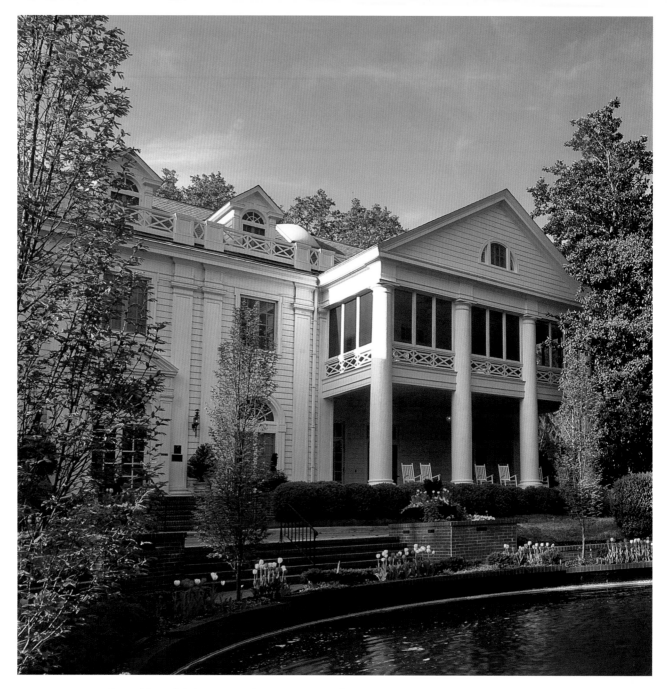

ABOVE: *Home of James B. Duke in Myers Park.* OPPOSITE, TOP: *Daniel Stowe Botanical Garden walkway; Daniel Stowe stained glass ceiling, c. early 1900s; it measures 22 feet in diameter and rises 9 feet in height.* BOTTOM: *Wing Haven gardens.*

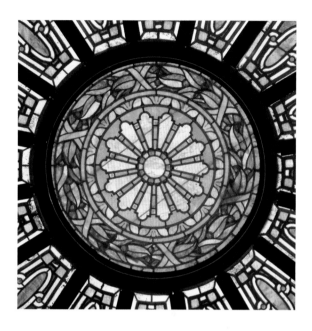

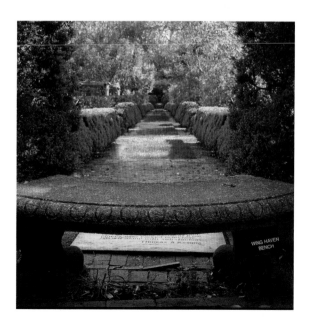

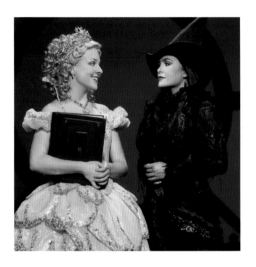

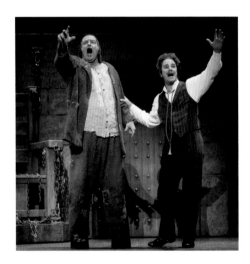

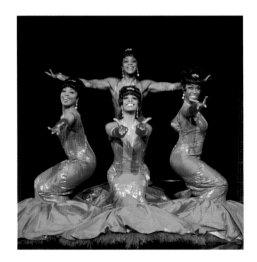

CLOCKWISE FROM TOP: *Blumenthal Performing Arts Center;* WICKED *(Ovens Auditorium) with Natalie Daradich and Vicki Noon;* YOUNG FRANKENSTEIN *(Belk Theater) with Roger Bart and Shuler Hensley;* DREAMGIRLS *(Belk Theater) with Nikki Kimbrough, Kimberly Marable, Felicia Boswell and Tallia Brinson as the Stepp Sisters.*

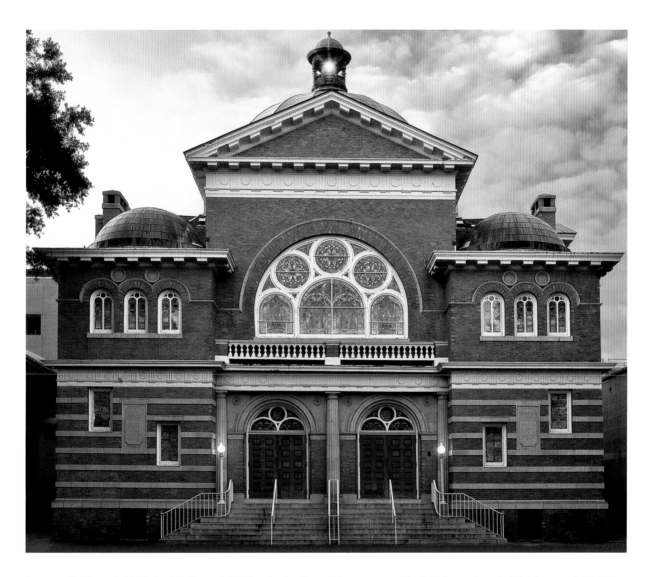

In uptown Charlotte, the North Carolina Blumenthal Performing Arts Center offers two venues plus Spirit Square (ABOVE) which is home to the McGlohon Theatre and the Duke Energy Theatre. Originally the First Baptist Church of Charlotte sanctuary, the old building was destined for destruction in 1975. Chairwoman of the Board of County Commissioners Liz Hair rallied citizens and saved the building. Spirit Square provides space for a variety of musical and theatrical performances, art classes, studios, and gallery space. In 1997, North Carolina Blumenthal Performing Arts Center took over the management of the Spirit Square facility. In addition, the Blumenthal also manages Ovens Auditorium, just minutes from uptown.

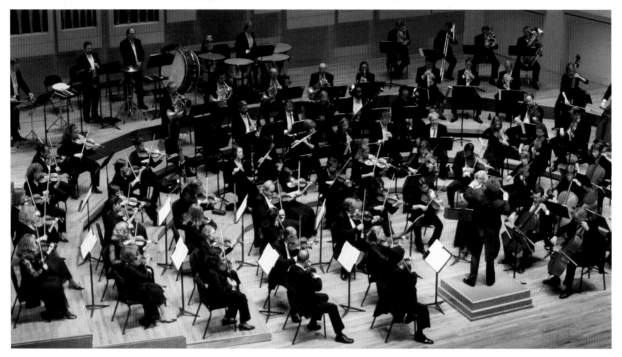

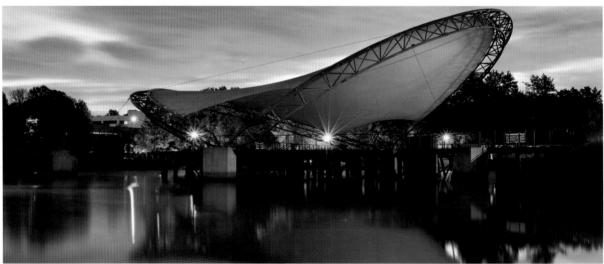

Founded in 1932, the Charlotte Symphony Orchestra has grown into one of the premier musical institutions in the Southeast, giving some 100 performances each season and reaching an annual attendance of more than 200,000 listeners. The Charlotte Symphony is the largest and most active professional performing arts organization in the central Carolinas, employing more than 100 professional musicians, 62 on full time contracts. The orchestra performs Classics, Pops, and Lollipops family concerts and produces a variety of educational programs for students of all ages. Its principal home is the acoustically acclaimed 1,970-seat Belk Theater of the Blumenthal Performing Arts Center; its summer home is Symphony Park at SouthPark.

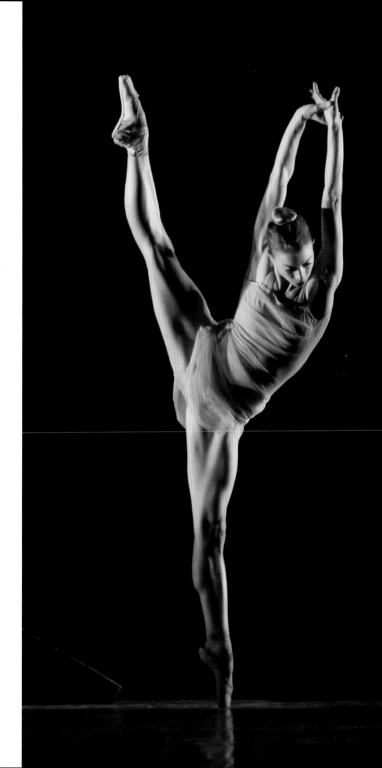

Professional ballet company, North Carolina Dance Theatre, is under the artistic direction of Jean-Pierre Bonnefoux and Patricia McBride, former stars of New York City Ballet. Described as "unstinting in range and thunder...a pleasure to behold," by The New York Times, NCDT is based on strong dancers, high energy and versatile performances, ranging from classical ballets like Nutcracker and Cinderella to bold, contemporary world premieres. Dance training, education, and outreach are priorities for the Company, with a School of Dance offering expert instruction to students working toward professional careers in dance and those interested in simply experiencing the joy and benefits of dance training.

Year Round Festivals

Throughout the year, the Queen City finds reasons to celebrate—from First Night Charlotte, a family-friendly New Year's Eve celebration, to a multitude of outdoor festivals such as the Loch Norman Games, Blues, Brews and BBQ, Yiasou, and the Carolina Renaissance Festival.

Sponsored and produced by Charlotte Center City Partners, First Night Charlotte showcases imaginative cultural events, music, arts, and dance for revelers of all ages.

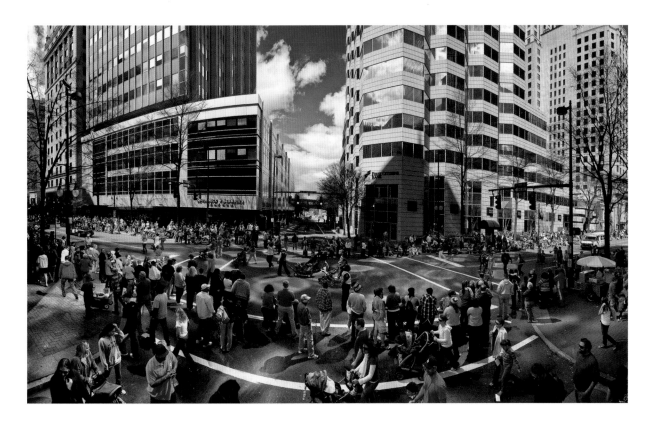

Charlotte's St. Patrick's Day Parade and Go Green Festival bring out a little bit of the Irish in everyone with creative floats, bagpipe bands, Irish Dancers and plenty of traditional Irish food and drink.

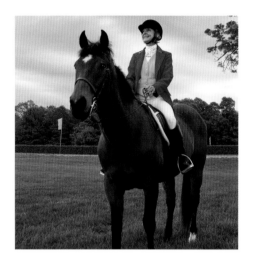
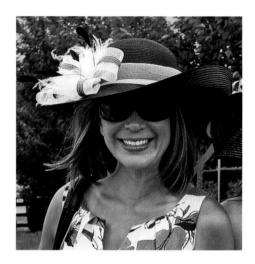

Charlotte's Queens Cup Steeplechase is an annual rite of spring. Every April, thousands witness jockeys and thoroughbreds vie for more than $100,000 in purse money as they compete on a two-and-a-half mile course of rolling turf. The Queens Cup is also a major social event with corporate hospitality tents and lawn boxes where fans come dressed in colorful spring outfits and memorable hats.

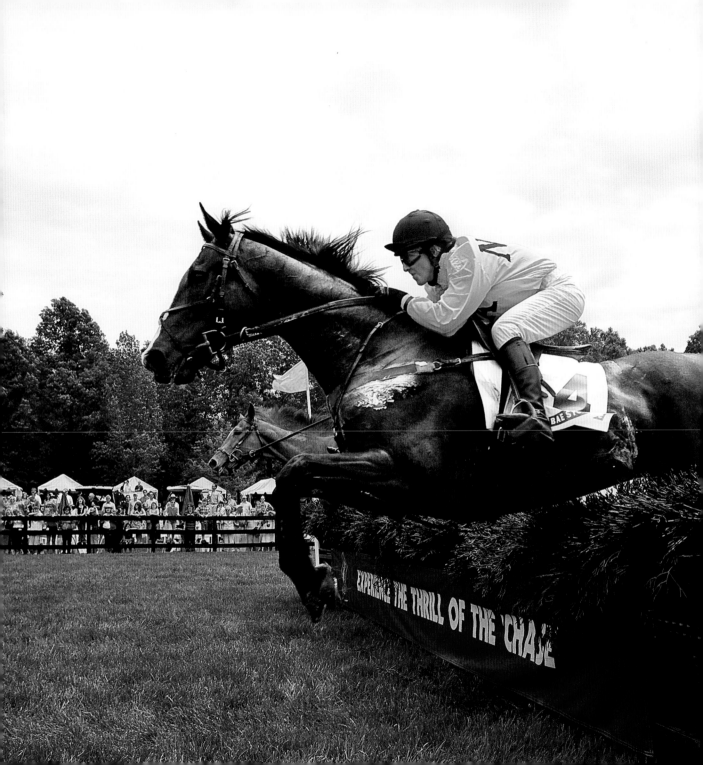

EXPERIENCE THE THRILL OF THE 'CHASE

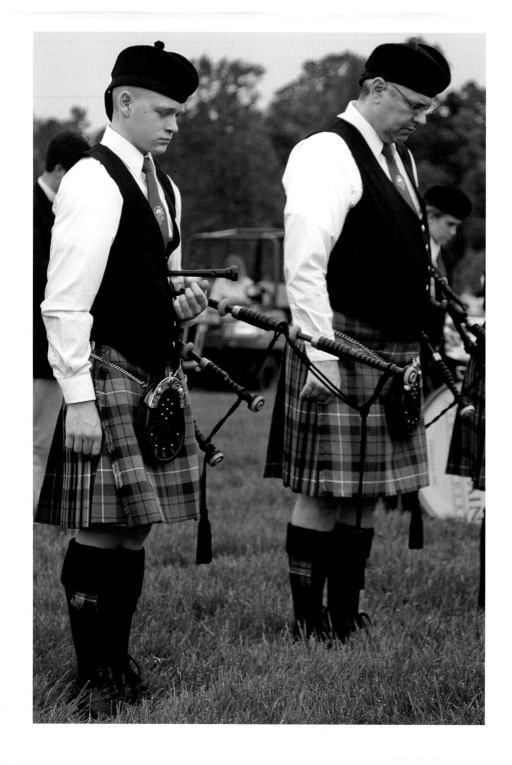

Charlotte Center City Partners sponsors the annual Blues, Brews and BBQ festival every September. The festival celebrates the best of southern cuisine and music with over 80 teams of barbeque masters who compete for $20,000 in prizes and bragging rights to the best barbeque in the South.

Every September since 1978, Holy Trinity Greek Orthodox Church has staged their Yiasou Greek Festival which features Hellenic cultural exhibits, authentic Greek cuisine, pastries, and entertainment. BELOW: The Ezvones Greek Presidential Guard, who normally preside over the tomb of the unknown soldier in Athens, Greece, are part of the celebration as they perform a colorful changing of the guard ceremony.

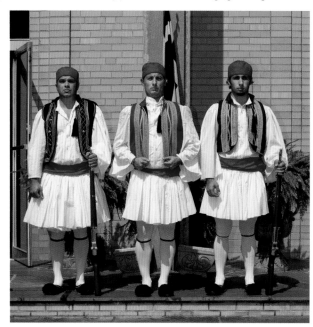

The Carolina Renaissance Festival is held weekends October through November in a 27-acre village filled with fun and excitement. The village boasts 10 stages, jousting tournaments, and an open air marketplace with over 100 artisans, shops, kitchens and pubs.

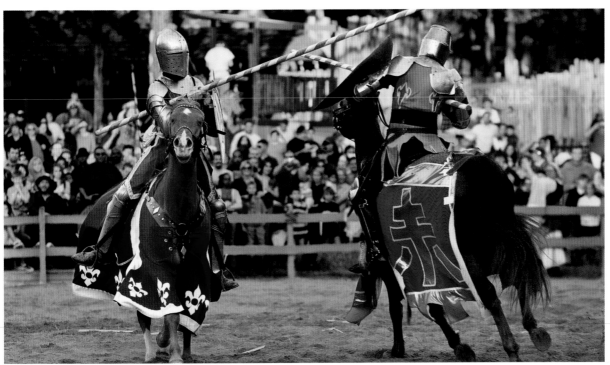

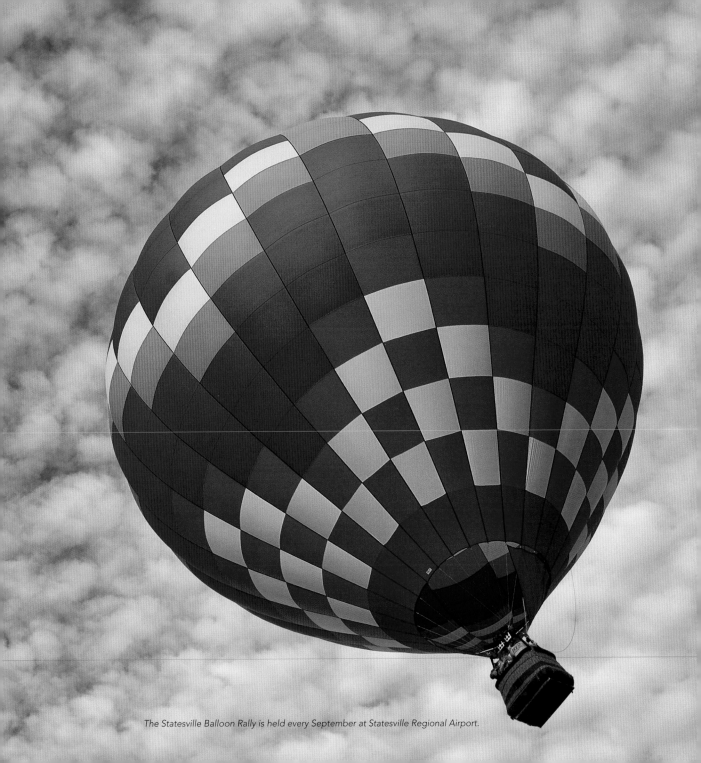

The Statesville Balloon Rally is held every September at Statesville Regional Airport.

A Charlotte Timeline

Catawba tribes are the first to populate the area. They are peaceful farmers and skilled craftsmen.

Charlotte's Town grows around the intersection of two native trading routes, the Nations Ford Trail south to Charlestown, and the Great Trading Path north to Virginia.

In 1762, Mecklenburg County is named after the birthplace of Queen Charlotte, the bride of England's King George, III.

1767 – Andrew Jackson is born in Waxhaw near the South Carolina Border and becomes the seventh President of the United States in 1829.

1775 – On May 20th, Mecklenburg delegates declare themselves free and independent from British rule and laws by signing the Mecklenburg Declaration of Independence that dissolves English laws and taxes.

1781 – General Davidson is killed in battle at Cowan's Ford. While the British gain a technical victory there, their losses are heavy and the tide turns against Cornwallis and his redcoats.

1795 – James K. Polk (11th U.S. President) is born in his family's cabin, near Pineville.

1799 – Conrad Reed discovers a 17-lb. gold nugget in Cabarrus County, igniting the Carolina gold rush.

1837 – The Charlotte branch of the U.S. Mint opens, stamping $5.00 Gold Eagle and $2.50 Quarter Gold Eagle coins. Over $10 million in gold coins are stamped at the Charlotte mint from 1837 to 1861.

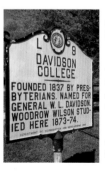

1837 – Davidson College is founded, and is named in honor of Revolutionary War hero, General W. L. Davidson.

1861 – On May, 20th, North Carolina secedes from the Union and joins the Confederacy. Charlotte's U.S. Mint is appropriated as Confederate headquarters. Mecklenburg Iron Works supplies the Confederacy with rifles and cannon balls.

1862 – Confederate Navy Yard is moved inland from Norfolk, Virginia to a location on Trade Street in Charlotte.

1865 - April 15th, Confederate President Jefferson Davis arrives in Charlotte for the last Confederate Cabinet meeting on April 20th. He and his Cabinet later visit the Springfield Plantation.

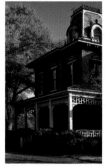

1869 – The *Charlotte Daily Observer* is founded.

1875 – William Henry Belk opens a store near the corner of Trade and Tryon Streets. This merchandising empire grows to 219 stores in 13 states.

1880 – D.A. Thompkins develops Atherton Mills village in Charlotte and pioneers the development of cotton seed oil. By 1904, Charlotte has 17 cotton mills; 300 mills are located within a 100-mile radius of Charlotte.

1890 – Edward Dilworth Latta establishes Dilworth, one of Charlotte's first suburbs. Latta's company was headquartered in the Latta Arcade on Tryon Street.

1893 – Electric street car system begins operation in Charlotte.

1900 – J.B. Ivey opens a store next to Belk's in the center of town.

1904 – Dr. Walker Gill Wylie and Dr. Robert H. Wylie realize the value of harnessing the power of the Catawba River and create the first hydroelectric power plant at Great Falls, South Carolina. Along with another pair of brothers, James Buchanan Duke and Benjamin Duke, they invest in a series of hydroelectric power plants and incorporate as Southern Power Company in 1905. This company ultimately becomes Duke Power.

1904 – Automobiles appear on Charlotte's streets.

1906 – James W. Cannon buys 600 acres of scrub land in Cabarrus County and builds the mill village of Kannapolis. His anchor mill has 4,000 yarn-making spindles. By 1914, Cannon Mills is the nation's largest manufacturer of durable flat-weave towels. By 1921, Cannon Mills has 165,000 spindles and 10,000 looms and is valued at $30 million. Charles A. Cannon, J.W.'s youngest child, takes over the textile empire at age 29, after his father's death in 1921.

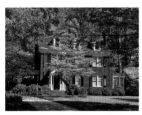

1912 – John Springs Myer and son-in-law George Stephens develop another Charlotte suburb, Myers Park, on the family's 1100-acre former plantation.

1914 – Ford Motor Company opens production plant in Charlotte. Production lines crank out 85 cars per day by 1918. (The plant closes in 1930.)

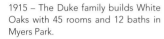

1915 – The Duke family builds White Oaks with 45 rooms and 12 baths in Myers Park.

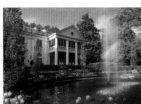

1917 – Camp Greene opens on Remount Road, housing 30,000 - 60,000 soldiers with headquarters in the Dowd farmhouse on Monument Avenue.

1918 – Billy Graham is born on a dairy farm in Charlotte.

1921 – WBT radio begins broadcasting from Charlotte.

1924 – Charlotte Speedway opens in Pineville, established by Osmond Barringer.

1927 – The Charlotte branch of the Federal Reserve Bank opens on the 20th floor of the First National Bank Building.

1930 – Charlotte is the largest city in North Carolina with 82,675 residents.

1936 – The U.S. Mint is dismantled and preservation efforts by Mary Myers Dwelle establish the Mint Museum of Art in the Eastover neighborhood.

1936 – Thanks to grants submitted by Mayor Ben Douglas, Charlotte's Municipal Airport opens. During WWII, the airport is used for military training and is called Morris Field.

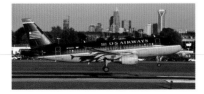

1942 – To honor soldiers who had died in battle, civic leaders raise funds to build Freedom Park.

1948 – NASCAR holds its first race in the stock division at the dirt track at Charlotte Motor Speedway. The May race in Charlotte draws the second largest attendance of any sporting event in the U.S., except for the Indianapolis 500.

1949 – Charlotte and Carver Colleges open, beginning Charlotte's community college system. In 1963, Carver College, later called Mecklenburg College, combines with the Industrial Education Center to create Piedmont Community College.

1959 – Cowan's Ford dam begun, creating Lake Norman, North Carolina's largest manmade lake with 520 miles of shoreline touching four counties. The lake reaches full pond in 1963.

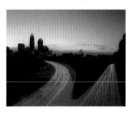

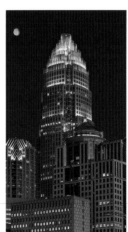

1972 – Interstate 77 opens, connecting Charlotte to Ohio.

1980 – Charlotte establishes a foreign trade zone.

1987 – George Shinn wins NBA expansion team, the Charlotte Hornets. Shinn later moves the team to New Orleans.

1992 – Nations Bank's 60-story corporate center, the tallest building in the Carolinas, is completed.

1994 – The Charlotte Convention Center opens.

1995 – Jerry Richardson is awarded NFL expansion team, the Carolina Panthers.

1995 – Charlotte's banking assets exceed $319 billion, making the city the second largest U.S. banking center.

1998 – B.F. Goodrich moves to Charlotte; Nations Bank merges with Bank of America.

1999 – TIAA-CREF moves to Charlotte.

2001 – SPX Corporation and Billy Graham Evangelistic Association move to Charlotte. First Union Corporation merges with Wachovia Corporation and changes its name to Wachovia.

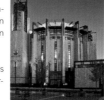

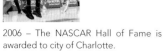

2002 – Johnson and Wales University moves to Charlotte.

2003 – NBA returns to Charlotte when the Charlotte Bobcats are awarded to Robert Johnson. Charlotte's banking resources exceed $1 trillion dollars. The city ranks fifth in the nation for number of Fortune 500 companies headquartered here.

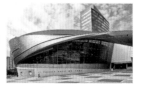

2006 – The NASCAR Hall of Fame is awarded to city of Charlotte.

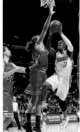

2007 – Lynx, the city's light rail line opens. The Billy Graham Library is dedicated and guests include Presidents Jimmy Carter, George Bush, and Bill Clinton.

2009 – Wachovia Corporation is acquired by Wells Fargo Bank, and becomes Wells Fargo's eastern headquarters.

2010 – Duke Energy Center opens, as does the Harvey Gantt Afro American Cultural Center, the Bechtler Museum of Art, and the NASCAR Hall of Fame.

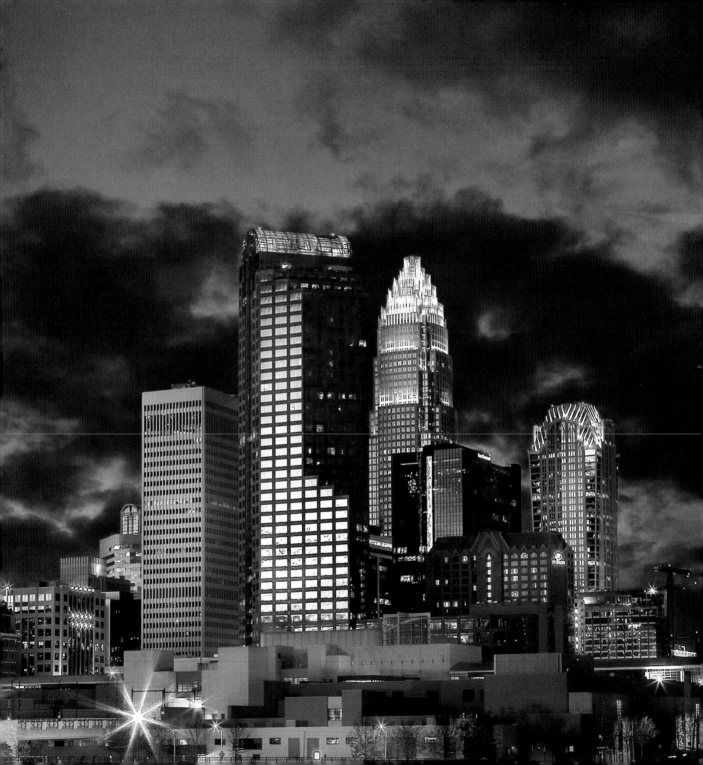

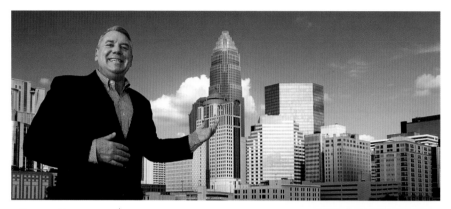

Greg Greenawalt

As a veteran with more than 30 years in destination, hospitality, and tourism sales and marketing, Greg Greenawalt has made his career promoting destinations and cities throughout the U.S. Originally from Elkhart, Indiana, Greenawalt has lived all over the country, from California and Florida, to Chicago and Philadelphia. He is President of Destination Concepts LLC and resides in greater Charlotte with his wife Cindi, daughter Alexandra, and their dog Max.

Paul Purser

Paul Purser—the man behind the camera—was born and raised in Charlotte, North Carolina. He's always found photography to be the ultimate creative outlet and whether hiking in the Appalachians, visiting the coast, or spending time in the Queen City, he's constantly on the lookout for images that tell stories. Purser is head photographer at Photo Charlotte LLC. When he's not taking pictures, Paul can be found on the golf course, fishing, or spending time with his wife Susan and son Jacob.

Acknowledgements

Allen Tate, Pat Riley, and Nancy Newman – ALLEN TATE REALTY
Crystal Emerick – ASPIRE COMMUNICATIONS
Karen Bernhardt and Tammy Gibson – BANK OF AMERICA
Diane Wise – BILLY GRAHAM EVANGELISTIC ASSOCIATION
Danny Knaub – BLUMENTHAL PERFORMING ARTS CENTER
Michael Morgan and Eric Gram – BOATING ON LAKE NORMAN
Jeffrey Gitomer – BUY GITOMER
Bryn Hough – CAROWINDS
Phyllis Beaver – CASTLE AND COOKE
Greg Good – AKA CATMAN
Ian Byrne – CAUDLE & SPEARS
Jeff McLeod – CIAA TOURNAMENT
Kristina Hill – CITY OF LIGHTS
Judy Smith – CHARLOTTE CATHOLIC DIOCESE
Michael Smith, Moira Quinn, and Robert Krumbine – CHARLOTTE CENTER
 CITY PARTNERS
Bob Morgan – CHARLOTTE CHAMBER OF COMMERCE
Captain Robert Brisley – CHARLOTTE FIRE DEPARTMENT
Patrick Stark – CHARLOTTE KNIGHTS
Lynn Saul – CHARLOTTE MECKLENBURG PARKS AND RECREATION
Carol Robinson – CHARLOTTE RAPTOR CENTER
Ronnie Bryant and Gina Howard – CHARLOTTE REGIONAL PARTNERSHIP
Dean Dennis Stone and Sharon Reichard – CHARLOTTE SCHOOL OF LAW
Tim Newman – CHARLOTTE REGIONAL VISITORS AUTHORITY
Jeff Beaver – CHARLOTTE SPORTS COMMISSION
Meg Whalen – CHARLOTTE SYMPHONY ORCHESTRA
Fred Klein – CHILDRESS KLEIN
Dan Griffis – CHIP GANASSI RACING TEAMS, INC.
Michele Gutt and Kim McMillian – CITY OF CHARLOTTE
Peg Morrison – CONCORD
Jim Hoffman – DANIEL STOWE BOTANICAL GARDEN
Marguerite Williams – DAVIDSON TOWN COMMISSIONER
Julia Allen and Debra Smul – DISCOVERY PLACE
David Scanzoni – DUKE ENERGY
Becky Farris – DUKE MANSION
Josh Braverman and Kathryn Knoespel Bray – FAMILY DOLLAR STORES
Sarah Baughman – FIFTH THIRD BANK
Harvey Gantt, GANTT, HUBERMAN ARCHITECTS
Mohammad Jenation – GREATER CHARLOTTE HOSPITALITY TOURISM ALLIANCE
Harold Hinson – HINSON PHOTOGRAPHY
Nicole Ritter – INDIAN LAND GIRLS VARSITY SOFTBALL
Melinda Law – JOHNSON AND WALES UNIVERSITY
Dr. Ron Carter, Joy Paige and LaVondra Farquharson – JOHNSON C. SMITH
 UNIVERSITY
Katie Stenavich – K.T. STUDIO
Cynthia Freeze – KEWAUNEE SCIENTIFIC CORPORATION
Patty Andrews – LAKE NORMAN

Pete Marriott – LAKE NORMAN YACHT CLUB
Kristen Oleson – LANCE
Niki Allen – LINCOLN HARRIS
John Daughtry – LOF PHOTOGRAPHY
Chris Ahern – LOWES COMPANIES
Scott Padgett – MAYOR, CITY OF CONCORD
Elizabeth Isenhour – MINT MUSEUM
Scott Duncan – NASCAR DRIVING EXPERIENCE
Winston Kelly and Kimberly Meesters – NASCAR HALL OF FAME
Logan McSwain – NORTH CAROLINA DANCE THEATRE
Kimberly Henderson – NOVANT HEALTH PRESBYTERIAN HEALTHCARE
Preston Smith – PRESBYTERIAN HOSPITAL
Bill and Carrington Price – QUEENS CUP STEEPLECHASE
Paige Gialanella – QUEENS UNIVERSITY
Jim Bailey, Eddie Burklin, Tyler Sigmon, and Jim Duncan – RED MOON
 MARKETING
Tim Rhodes – RUN FOR YOUR LIFE
Janie Allen – SALISBURY HISTORIC MURAL
Bruton Smith, Scott Cooper, and Donna Lawing – SPEEDWAY MOTORSPORTS
Carole Williams – STEELE CREEK RAGE LITTLE LEAGUE
Ashley Oster – UNC-CHARLOTTE
Chuck Allen and Michele Mohr – U.S. AIRWAYS
Joe Clontz – VICTORY LANE RACING
Mike Butts, Susan Schwint, Linda Durkin – VISIT CHARLOTTE
Jay Everett – WACHOVIA / WELLS FARGO
Kym Hougham – WELLS FARGO CHAMPIONSHIP

and
Scott Stallings – ASSISTANT TO PHOTOGRAPHER PAUL PURSER

Selected Bibliography

2009 Fiscal Year in Review. Charlotte Regional Visitors Authority, June 2009.

2009 Charlotte Visitors Guide. Visit Charlotte and the Charlotte Regional Visitors Authority.

2010 Official Visitors Guide. Visit Charlotte and the Charlotte Regional Visitors Authority.

Believable Brands Research Report. Commissioned study, Charlotte Regional Visitors Authority, 2008.

Boykin, Sam. "Profile Charlotte." *U.S. Airways Magazine*. Destination Publications, June 2008.

Bryant, Ronnie. *Charlotte Regional Partnership Annual Program of Work Report*. July, 2008.

Butts, Mike. *Visit Charlotte, Fiscal Year 2010 Sales and Marketing Plan*. June, 2009.

Campbell, Dr. Harry; et al. *2010 Newcomer Resources, Venture Charlotte Magazine Winter 2009/2010*, Charlotte Chamber of Commerce, 2009.

Campbell, Jr. Harrison S. *Benchmark Charlotte 2009*. Charlotte Chamber of Commerce, June, 2009.

Center City Charlotte Brochure. Charlotte Center City Partners, 2009.

Charlotte Chronology. Charlotte Chamber of Commerce, 2008.

Connections Newsletter. Public Affairs Department, Charlotte International Airport, Spring, 2009.

Dillard, Megan; et al. *Charlotte Chamber of Commerce Membership Directory, 2009 Newcomer Resources*. Charlotte Chamber of Commerce, 2009.

Edge, Jeff. "Ventures Charlotte." *Boom Charlotte*. Winter 2009/2010. Charlotte Chamber of Commerce, 2009.

Garloch, Karen. "Lifestyle, Health and Healthcare Giants Compete for Business." *Living Here Magazine*. The Charlotte Observer. September 27, 2009.

George, Jefferson. "Business Airport Fortune 500 Charlotte's Airport One of the Busiest." *Living Here Magazine*. The Charlotte Observer. September 27, 2009.

Henderson, Bruce. "Carolinas Nuclear Corridor Poised to Fuel Growth." *The Charlotte Observer*. October 27, 2009.

Henry, Alison. "Education Colleges/Universities." *Living Here Magazine*. The Charlotte Observer. September 27, 2009.

Kelly, Winston. Personal interview. 24 February, 2010.

Kratt, Mary. *Charlotte North Carolina, A Brief History*. Charleston SC: The History Press, 2009.

Marusak, Joe. "Lake Area Remains a Magnet for Growth." *Living Here Magazine, The Charlotte Observer*. May 3, 2009.

Pottman, Lore. "The Essence of Charlotte." Charlotte Chamber of Commerce, December, 2008.

Quirk, Bea. "Training and Education, Institutions Lend a Hand." *Charlotte Bound. Charlotte Business Journal*. August 28, 2009.

Rindoks, Leslie. *A Town By Any Other Name*. Davidson, NC: Lorimer Press, 2005.

Rindoks, Leslie. *The Psalm Singers of Concord Town*. Davidson, NC: Lorimer Press, 2004.

Rothacker, Rick. "Business Banking Big Changes, Tough Times in Charlotte" *Living Here Magazine*. The Charlotte Observer. September 27, 2009.

Ryan, Deborah E. *What's Right About Our Region*. Charlotte, NC: Blurb, 2006.

Smith, Bruton. Personal interview. January, 2010.

"Spring /Summer 2010 Guide." *Get Going Magazine*. Mecklenburg County Parks and Recreation, 2010.

Stabley, Susan. "International Companies Enjoy Beneficial Climate." *Charlotte Bound. The Charlotte Business Journal*. August 28, 2009.

Tate, Allen. Personal interview. 26 February, 2010.

Tate, Lori K. "Profile Charlotte." *U.S. Airways Magazine*. Destination Publications. June 2008.

Tomlinson, Tommy, "Your Guide to the Region 2009/2010." *Living Here Magazine*. The Charlotte Observer. September 27, 2009.

Williams, Marguerite. Personal interview. 28 April, 2010.

Internet Sources

"A Partnership in Higher Education." *www.CharlotteChamber.com*. December 28, 2009.

About Billy Graham. *www.BillyGraham.org*. June 12, 2010.

About Center City. *www.CharlotteCenterCity.org*. November 23, 2009.

About History. *firstpres-charlotte.org*. March 3, 2010.

About/Mission. *www.carolinaraptorcenter.org*. June 12, 2010.

"Bench Mark Charlotte 2009." *www.CharlotteChamber.com*. June 10, 2009.

Biographies/profiles. *www.BillyGraham.org*. June 12, 2010.

"Charlotte EpiCentre." *www.epicentrenc.com*. June 12, 2010 .

"Charlotte USA Industry, Charlotte Region, Quality of Life." *www.CharlotteUSA.com*. March 8, 2010 .

"Cultural Data and Publications." *www.artsandscience.org*. September 18, 2009.

"Demographics and Economic Profile." *www.CharlotteChamber.com*. January 10, 2010.

Hanchett, Dr. Thomas W. "Dilworth." *www.cmhpf.org/educationneighhistdilworth2.htm*. April 10, 2010.

Historic Latta Plantation. *www.lattaplantation.org*. June 12, 2010.

Historic Properties, Local History, Charlotte Mecklenburg Historic Landmarks Commission. *www.cmhpf.org*. October 6, 2009.

History of Fort Mill. *www.fortmillliving.com*. June 12, 2010.

Knights Info/Team History. *www.charlotteknights.com*. June 12, 2010.

Morrill, Dr. Dan L. "Court Arcade." March 24, 1980. *www.landmarkscommission.org/essay.htm*. April 10, 2010.

NCState University. *www.ncresearchcampus.net/universities*. May 4, 2010.

Official Historic Charlotte Magazine. *www.historicCharlotte.org*. January 14, 2010.

Quality of Life. *www.CharlotteChamber.com*. February 9, 2010.

Solender, Michael J. "Sculptor Fondly Recalls." February 28, 2010. *www.charlotteobserver.com*. April 13, 2010.

"Visit NC, To Play." Carolina Culture, State of North Carolina. *www.ncgov.com*. February 23, 2010.

"Visitors and Residents, Calendar of Events." *www.charlottesgotalot.com*. December 8, 2009.

Youngblood, David. "Short History of Springs Farm." *www.springsfarm.com/history*. June 12, 2010.

Additional Copyrights & Permissions

Photographs page 19, courtesy of Marguerite Williams

Photograph page 32, courtesy of Piedmont Farmers Market

Photographs page 33, courtesy of Piedmont Farmers Market

Strawberries page 33, © Richard Hoffkins

Tomato page 33, © Ed Isaacs

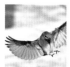 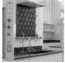 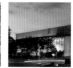

Bluebird page 35, © John Daughtry

Photograph page 45, courtesy of Johnson C. Smith University

Photograph page 63, © Jeff Siner *The Charlotte Observer*

Lab photographs page 67, courtesy of Kewaunee Scientific Corporation

Photograph page 83, courtesy of Lance, Inc.

Photograph page 84, © Todd Hess, Vertis Communications

Photograph page 84, © Richard Boyd

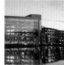 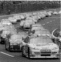

Photograph page 85, courtesy of Lowes Companies

Photograph pages 86-87, courtesy of Chip Ganassi Racing Teams, Inc.

Photograph page 96, © 2009 Kent Smith/NBAE via Getty Images

Photograph page 99, © 2009 Chris Keane via Getty Images

Photographs page 103, © HHP/Harold HInson

Photographs pages 108-109, © HHP/Harold HInson

Photograph pages 114-115, courtesy of Carole Williams

Photograph page 118, courtesy of Neil Elam

Photograph page 122, courtesy of Concord Mills

Photographs page 129, © Oscar Williams

Photograph page 134, © Tom Johnson

Photograph page 134, © Paul Kolnik

Photographs page 134, © Joan Marcus

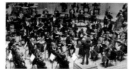

Photograph page 136, © Nancy Donaldson

Photograph page 137, © Peter Zay

Photographs page 137, © Jeff Cravotta

156

Index

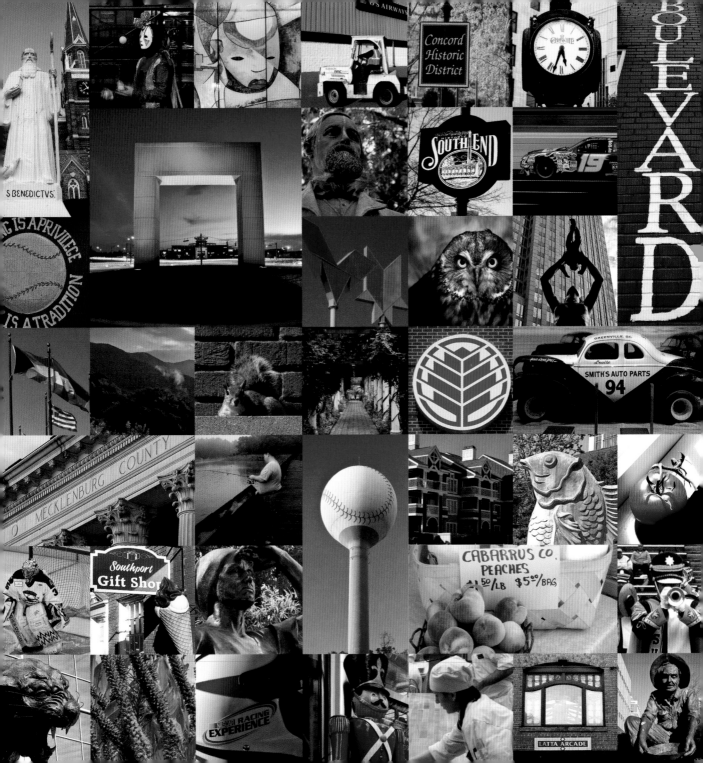

Fresco by Ben Long in the TransAmerica Building